GEORGANN
LOW

Dancing Alone by Georgann Low

191 University Blvd., Box 443, Denver, CO 80206

ISBN 978-1-94424-309-8

First Edition

Edited by Barbara Scott, Final Eyes, Taos, New Mexico

Designed by Lesley Cox, Feel Design Associates, Taos, New Mexico

avec des anges !

REAL FEARLESSNESS IS THE PRODUCT OF
OUR TENDERNESS. IT COMES FROM LETTING THE
WORLD TICKLE YOUR RAW AND BEAUTIFUL HEART.

— CHÖGYAM TRUNGPA RINPOCHE

You're a fool whether you dance or not
so you might as well dance!
~ some Budkiot

present

September 2001 began a time of deep collective confusion and transformation for America. The ground was shifting under our feet, and we had lost our sense of control. These changes seemed to also be transpiring in many of us on a personal level. It was as if, to some extent, the chaos was reflected deep within our own psyches.

On the morning of 9/11, I was dancing to Ray Charles in my living room when my neighbor called to tell me of the horrific events unfolding in Manhattan. Stunned, I hung up the phone and felt strangely quiet. It occurred to me that I should turn off the music and continue to move, to dance — not the playful, exuberant welcoming of this new day but a very slow, aching sort of concentrated movement in which I allowed my fearful heart to guide me.

Feeling the energy of that moment moving through my body, I remember trying to transmute my quiet panic into some kind of expression of love and healing. Trying to reach beyond the walls of my house, I began to feel a deep connection with America, with my people, as if we were all voices of the same cosmic cry of terror and outrage.

The intense inner work I've been involved with over the past years began just before 9/11. Now, finally, out of the anguish, confusion, and guilt at the shock waves my inner process was generating — the pure bone-shaking fear of wrestling my demons — I've begun to move toward fuller integration of distant yet potent parts of myself. A new tenderness and acceptance of self and others begins to emerge as I pass through the loneliness of introspection into a deeper connectedness with the world. At times it feels as if my heart holds all human beings. As if I've fallen in love with humankind.

Speaking of transformation, an acupuncturist/healer I know says that perhaps if women could grasp the opportunity to change which menopause gives us and move into deeper

authenticity, rebirthing ourselves in middle age, the incidence of disease, like cancers of self-negation, would diminish in us. We would no longer store in our hearts the intense misgivings and frustrations of living the pointless stories others have written for us.

I have sifted through stacks of my drawings, journals, and dream books, making sense (or trying to) from all the thought ramblings and intense colors of those times. My hope is that others may hear their own soul call and grant themselves permission to go a little bit crazy. That they may find themselves in a brave new world of infinite possibility. It is through healing ourselves that there is hope for healing our planet.

Dancing Alone.

georganlow.

off to find
the bluebird of
happiness.

I am a writer in my own mind. I've always had a flowing narrative in my head about my life as I am living it — my story. I think it's because I started reading books from my mother's library at an early age. I loved the Wizard of Oz series by Frank Baum, which she had kept from her own childhood. As I slowly made my way through them, Oz became my main reality, which didn't seem to bother anyone much. Later on the eighteenth- and nineteenth-century British novels I found on her shelves became my refuge, and for a time Jane Eyre was my closest friend. (Once I even tried reading Marcel Proust because I liked the book cover. Reading very slowly and painstakingly something about the sun shining through the windows on crystal goblets appealed to me. Otherwise I couldn't figure out what the hell he was talking about!)

Since I was very young, I've filled notebooks with words and drawings, dreams, and an occasional poem. When I was around fourteen or fifteen, and had turned toward Kerouac and Ginsberg, I wrote a poem which, for some bizarre reason, has stuck with me:

> THE ROOM WAS ROTTEN WITH RATS,
> BATS CLUNG TO THE WALLS,
> AND ON THE FLOOR AROUND THE PIT,
> A ROBUST AARDVARK CRAWLS.

To create the right sort of reality for myself, I found an old, dark velvet smoking jacket in a thrift store and hung it over one window of my cheery, middle-class bedroom. I hauled home bits of junk from back alleys — a spoked wheel from an old car that reminded me of a sunburst, random boards with interesting spatters and splotches of paint, rusty cans, pigeon feathers, and lots of candles and rocks. To the dismay of my mother, my room (where I was spending more and more time) became a beatnik den, where I imagined myself sharing my dark poetry to the sounds of bongo drums and one hand clapping.

My writings and drawings are my soul's companions. They were made haphazardly as the spirit moved me — either through uncontainable joy, angst, or just the solitary absurdity of me moving through my days. Today I write to stay connected with myself, to feel less strange and alien in the world. For me, the blank page has always been a true and trusted friend, a sacred ally not necessarily shared with anyone else. But recently when I heard someone say, lamenting her desolate marriage, "I dream of leaving him and starting my own life but I'm afraid I haven't the will to do it," I decided to dig out some journals from my more recent struggles. They were stuffed into a large basmati rice sack in the top of my closet shoved behind a ratty old feather boa from Paris and my dead father's Stetson hat. I'd stashed them there because they weren't for anyone else to see.

It seemed a daunting task to piece together these bits and tatters of paper, like trying to organize zillions of thoughts and put them in an order, presenting them so that someone outside myself could make sense of the whole damn thing. Telling my story of the past ten years in concise chronology was difficult if not impossible. Things seemed to happen simultaneously on different levels, especially in hindsight.

But since writing and drawing had helped me through an enormous transition, perhaps the chronicles of my changes could help others navigate dark times and troubled waters, the glimmering hope and nagging fears that come from big change. Reading through my dusty writings brought back full force the anguish and confusion, along with the breathless expectation of those times. Now, years later, I feel as if I have awakened from a frenzied nightmare into a morning filled with sunlight and birdsong. Some of the writing seems overblown and ponderous, but I'll keep it as the voice of that time. It is the work of my own hero's journey, my own odyssey. And I smile at my younger self and hold her in my arms and say, "Don't worry, things will work out."

Looking back, I see myself as a small, frightened woman alone without a compass. Trembling in the darkness, she was brave, I think, to whisper Yes when the Goddess of Change beckoned her to follow. Brave and foolhardy, I see her standing there poised, like The Fool in the Tarot cards, on one tiptoe at the edge of a cliff.

As violent shock waves issue from subterranean movement, my changes would affect everyone around me. Early on I dreamed of the ferocious six-armed Hindu goddess, Kali, who manifests in order to destroy ignorance and delusion, thus creating new growth and authenticity. (I've found, however, that she is not without compassion.) At times, I embodied that same sharp, penetrating warrior energy, which, after years of always trying to be "nice," frightened everyone around me, including me.

I see myself there, standing in front of our house in the suburbs, waving and smiling. I am holding a plate of cookies. I have one arm around my husband and one around each of my three kids — and so far that is five or six arms, including the cookies and the waving (the Goddess Kali before she gets really pissed off!). The problem was that in constantly taking care of others and trying to make everyone happy, I forgot myself. I tried not to. Finding little time for my art, I resigned myself to carrying around a little sketch pad. I drew at piano lessons, ballet classes, coffee shops, at my kitchen table — sometimes with my kids yelling and fighting around me. One time, to my amazement, a cop appeared in the corner of my garden as I was blissfully drawing flowers.

It was a warm, sunny day and school was out for the summer. I had vaguely heard shouts coming from the house. This in itself was not unusual. My kids fought and hollered a lot, and I never could figure out who was really at fault. So I tuned it out and went on with my drawing. I was unaware that my eight-year-old daughter, seeking a more viable authority figure than her mother to punish her offending brothers, had dialed 911!

He was nice, the cop, and it was obviously the usual sort of sibling squabble, so he left, and as I remember, I took the three of them to the swimming pool. Oddly enough when I think back, those days were sort of blissful in spite of all the yelling and hollering.

Everyone in my family seemed to have me pegged. I was "Mom." Mom this, Mom that. "Never mind, it's just Mom." I often felt like the fall guy, which, I think, means the one they put their frustrations on. The scapegoat.

My husband, on the other hand, was "DAD." Dad was cool. He believed in flying saucers and conspiracy theories and was generally groovy. I wasn't. I was uptight. I could hardly breathe I was so fixated on keeping everything together. OK, I was a passionate control freak, definitely not groovy. I felt that they all kind of talked about me when I wasn't there. (Paranoid too!) Soon enough my children were in their late teens and early twenties, and I was grieving the onslaught of the empty nest. I was also bored with myself.

It was subtle, though. When I noticed my unhappiness out of the corner of my eye, I would quickly convince myself that there was nothing wrong. And besides, it was probably my fault, whatever it was, and my duty to fix it, to try harder. I was in an uncomfortable little box created by my own expectations, as well as those of others. I felt unreal and empty, like I was only half there. I didn't fully inhabit my body or my life.

My husband tried to be supportive of me. He loved me. But I still was not happy. It is hard to write about this, because I don't want to in any way diminish our marriage, which for many years gave me happiness and contentment. Looking back, I think these were indeed my changes and didn't have a whole lot to do with him. He didn't fail me. He was good to me. We were looked upon as an ideal family.

But there were imbalances, as exist in most relationships, and I was at a point where I couldn't find a way to become myself and be married. Something in me — or the unconscious projections from those around me — was keeping me from entering into a vast, unexplored territory, my solitary journey toward wholeness. But I had heard the call and would follow. My life depended on it.

What are these crazy
thoughts that come to
me from the moon?
 Is it you? or is it me?
 or is it me, or is it you?

It is me. I know for sure.
 Singing to that Rock
 in the gully,
 down the red path,
 through the sweet-smelling
wild sage
 It's me all right.
Dancing naked under the moon
at night as if my sanity depended
 on it — which it does.

I remember walking the trail near my house where it descended into a gully. I would stop by a particular rock — a red sandstone boulder larger than me — where I could hear the sound of water flowing into the creek below. Standing there, I would open my mouth and sing out a meandering wordless chant, which sounded kind of Native American or Middle Eastern — full-throated, the way I imagined birds sang. I sang the Earth, the beauty of the sunrise, the red clay path, and my longing to find my real voice. (Joggers running nearby politely kept their distance!)

I stumbled upon a book on chakras at a used-book store. Having taught hatha yoga for some years, I was always looking for a deeper explanation of how these cerebral-spinal centers impact our lives. Sitting at the table with my husband in the crowded bookstore, I haphazardly opened the book to the chapter on the third chakra, Manipura, the solar-plexus center of feeling and empowerment, and gazed at the vibrant, pulsating colors of the lotus image.

Suddenly the noise around me seemed to quiet as my breath slowed and expanded. In the dreamlike stillness, an inner eloquence told me I was truly alone, and I realized that it was more important for me to communicate with myself than with anyone else, that I must learn to accept and digest my true feelings about my life. This was my work from then on. As I began to move through this process of growth, it was painful, even shattering, not only for me but for those around me.

One day in the car, I was talking about some of my struggles with my seventeen-year-old daughter who has always been wise beyond her years. She said to me, "Mom, you need to see a shrink." In my excitement, I nearly drove off the road. I had taken my children for counseling at various stages of their growth but never felt I had the time or money to seek help myself. Maybe if I had, I could have moved with more grace through what was now confronting me. But at that moment I felt an invisible hand reach out and take mine, drawing me firmly toward my future.

I stumbled into my first therapy session and stated point blank, "I am married to a wonderful, supportive man who loves me dearly, and I don't want to get a divorce!" In fact some variation of this affirmation would begin my next few sessions before we began to expose the layers of self-deception floating beneath the surface. I liked talking about what was going on in a sort of abstract way, steering clear of the deeper feelings. But she, with her eagle eye, wouldn't let me. She would pull me out of the clouds of denial into pure and stunning clarity, into the realm of long-repressed feelings. I was excited and terrified. Like a shaman/midwife, she seemed to be facilitating the intense process of me giving birth to myself. My therapist helped me breathe and stay present. "Be with it," she would say.

Sometimes after these sessions I'd go to the same bookstore where I'd found the book on chakras. It was a Buddhist bookstore in Boulder, and it reminded me of the year I'd spent at Naropa studying meditation before I was married. As I was sipping an espresso there, I got to thinking of Rinpoche (we just called him Rinpoche but his name was Chögyam Trungpa Rinpoche).

It was another of those moments when, in the midst of my rambling and often at that time anguished thoughts, I received a clear insight from I'm not sure where. From my soul, I think.

It was as if Rinpoche was saying to me that I had completed a full cycle. As if he said, "You have become what you longed to be when you were a student here. You are a mother. Now it is time to move into another life as well." I wish I could express it better. It was as if I'd stepped into another realm and I didn't need to feel guilty about it because it was my journey.

I began to open more deeply to my feminine nature. Sometimes lying in bed at night or meditating at my little altar, I would feel such exquisite streams of energy flowing, vibrating powerfully through me. Perhaps they were hot flashes, but I felt that I was being purified physically and spiritually by them. I sensed a new vibrancy in my self, as if I were able to embody or transmute more energy through my nervous system. "Go ahead," I would pray, "change me. I am ready to change."

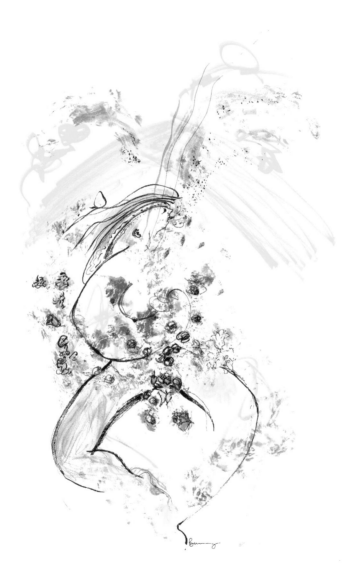

So this was menopause. I hated the word. It reminded me of my mother and her bridge-club ladies talking about it in hushed tones as something utterly distasteful but absolutely unavoidable—some awful thing that happened to all women on top of everything else they had to endure. I was pretty sure it would never happen to me, as I sneaked around stealing handfuls of M&M's from the silver candy dishes, because I couldn't imagine ever being like those women.

In fact, my own experience of this transition was so different. I was feeling enormously empowered and more deeply myself. And I was becoming lighter, physically. Extra weight I had been carrying for years, perhaps to hold myself down, was no longer necessary. It just seemed to vanish. I felt I was casting off an intolerably heavy mantle of psychic debris, layer upon layer of filthy, ill-fitting clothes worn summer and winter to keep me hidden. I was naked to the soft, fresh breeze of new growth, greeting a new day and a new world, a world beyond the roles I had played for a thousand years. I was coming out of the darkness. I was discovering that this change, or "THE CHANGE," as my mother had called it, was actually my link to all women—past, present, future.

I thought of my ancestors, the women, one by one—the ones whose stories I'd heard. They were strong, loving women. Some were well educated, though they never had careers. Always they stayed married, devoting themselves to their husbands and families. One of them, my paternal great grandmother, Cecelia, raised several children. All of the male children were very successful in business. I have seen a photo of them in their dark business suits looking very serious. Apparently my grandfather was the one who laughed and joked a lot, but he died young. And I remember the formal, patriarchal gatherings at the home of Great Uncle Hugo, the head of the company. I see the big, dark-paneled living room and the glorious Christmas tree with it's unearthly glow, pulsating, it seemed to me, with fairies or angels no one else seemed to notice.

Other than the tree and the sweets baked by aunts and served on silver dishes, these were rather somber, well-behaved affairs, which usually drove me to do something wild. Often my younger second cousins would sing carols and curtsy to the applause. Once I rambunctiously rocked them in a rocking chair until they flew out, landing like large blond confections — cream puffs — on the Oriental carpet. I was mortified, disgraced in front of the whole family. I felt so appalled by what I'd done that I blurted out in tears, "Nobody likes me, and Uncle Hugo hates me!"

Of course Great Grandmother Cecelia wasn't there. If she had been, I think she might have given me some bit of comfort, found some way to forgive me, because she loved children. Unfortunately, her last child, whom she had given birth to at age forty-something, died in infancy. She plunged into depression and, some say, madness. I can see her sitting alone in the mental institution and imagine her sorrowful death. Her children carried the sadness with them.

I wonder if her slide into "madness" might have had something to do with menopause. Women in those days were expected to button up and keep a tight lid on it. Otherwise, what good were they? I can imagine that she may have had some of the same feelings I was having, but there was no therapist or women's group. She probably couldn't skulk around her house late at night drawing pictures of the moon on the walls. (Or maybe that's exactly what she did.)

Fortunately for me, I was for the most part raised to be an independent and creative spirit, so I afforded myself the space to go a little nuts. But my gifts come from her and others like her, and I often think that we are living our lives, as Carl Jung wrote, to answer the questions or the dilemmas of our ancestors.

This morning's meditation,
early by candlelight.
I reach back into the past
to take the hands of my sweet
great great great great
grandmothers,
There in the half light of
history.... and just as I reach
back to them with my soul,
I feel suddenly my children's
children reach to me with
their love.
The past and the future
are helping me.

I remember my delightful Italian/French grandmother, my mother's mother, who sang to me and taught me to play *I Found My Thrill on Blueberry Hill* on the piano. Nonie also inspired me to draw. On the white cardboard that wrapped my grandfather's shirts from the cleaners, she would draw a squiggle and then get me to make it into something (usually a swan). Then we would go outside and look at clouds from her front porch, and she would ask me what I saw. We liked being together, my grandmother and I. In later years, after my grandfather died, she fell in love with oil painting and finally got to release the artist within. I also remember that in some ways she seemed lonelier when he was alive. He always thought she talked too much.

Don't get me wrong. I adored my grandfather. He was kind and noble and generous. The men in my family were a talented, hardworking bunch, and it's thanks to them that I have the leisure time to sit here and write my story. It wasn't that they were mean to their women. It was more a matter of the times in which they lived, not who they were.

From our perspective, we can see that there was an imbalance in gender roles at that time. Given the strict societal guidelines, people didn't have much choice in how they could manifest their natures. Both men and women were often stuck in unfulfilling and uncompromising roles, in marriage and in society, which didn't necessarily engender true happiness. They did their duty, but beneath the surface of appearances, they were suffering. I must reveal that when Uncle Hugo died, his wife, Aunt Augusta, fled to San Diego and lived the high life with her two spinster sisters and a couple of young gay-guy escorts. Upon her death she left all of Uncle Hugo's money to the escorts.

During menopause, most of my friends were on some sort of hormone-replacement therapy. I decided to use acupuncture and herbs instead. I wanted to allow this transformation its fullest expression and not to block it. Just when I had thought I would slip into a somewhat predictable future, I found myself on a wild ride into the unknown. All the creative energy, which had been focused mainly on others, came gushing and burbling up from the depths. Sometimes I imagined I was alone in a little sailboat drifting out to sea. Sometimes I felt I was flying, exhilarated, held aloft by angels. I was lost and found at the same time.

Thus this midlife change, which I had always heard described as a flat dulling down — the end of my feminine potential — was in fact a time of renewal and self-healing. It was like a giant orgasm sweeping me along on its tsunamic wave. It shook me awake. In the middle of the night, I would climb the stairs to the little room I had claimed as my studio. I would paint and draw with abandon, not caring what it looked like.

It was transformational expression — pure emotion flowing onto the paper. I would barely look at my creation, allowing my hand to be guided, trusting in my unconscious to communicate. Exploring the cracks and fissures of my psyche, I discovered marvelous openings into brightly colored realms. I created doors to pass through. And I created women, mother figures, goddesses dancing and blessing, calling to me.

One early drawing from that period is a woman dressed like an Eskimo but without shoes. She stands within a lunar landscape, arms uplifted. As my late-night art orgies continued, the women became wilder, more erotic, in brilliant yellows and oranges, dancing over the paper in fierce, liberated movement. One canvas is the face of a woman with bright blue eyes, holding up her hands as if to shield herself from the light of the burning sun. I realized that the colors I was drawn to were associated with the lower chakras. The work

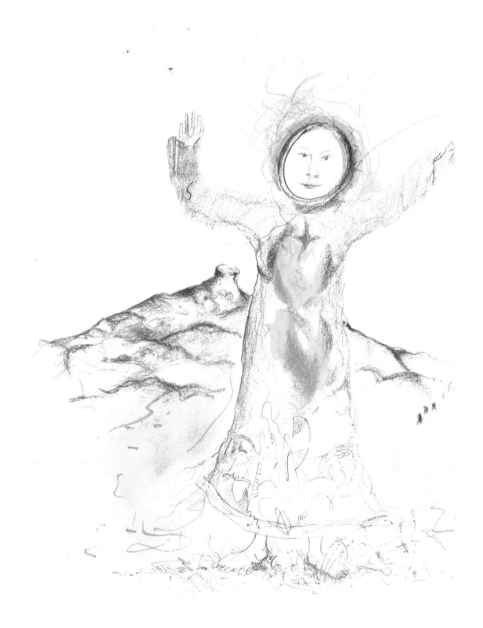

I was doing involved liberating the identity and the energy of these areas of myself—my rootedness, my joyous sexuality, and the empowerment of my truest feelings—aspects of myself I had toned way down and pushed back, somewhere along the line.

My dreams were shifting also, as in this one I scribbled on a note pad I'd started keeping by my bed. "I'm in a high rise by the blue beautiful ocean. People are glad to see me. They've heard of me and seem to know me. I'm bringing my sister along too. One woman says, 'You look just like Yoko Ono.'" In another dream, the car my husband and I were in hadn't enough power to make it up a hill. I jumped out and found myself alone, wandering along a path lined with vibrant gemstones. Often I was visited by women much like myself, who seemed to be trying to tell me something important that was hard to hear. What I did understand was that they clearly recognized and encouraged me. They seemed to admire my courage.

By far the most powerful dream was the Native American woman, with eyes like my mother's, riding on the back of an enormous black bear. I was very small and frightened, but I could see that she had complete control over the beast. His savage strength yielded to what I can only describe as her power of beatitude, like a dark-skinned Indian Madonna with eyes that shone like the cosmos itself and yet were deeply, deeply human. Drinking in her gaze I felt healed, surrounded by compassionate grace.

As I careened through the divorce, some of my friends and family rejected me. They thought I had lost my mind. To some, I represented evil incarnate for hurting such a nice man. Others seemed to feel threatened by what I had done, as if it put their own relationships up for grabs. Rumors began flying around that I was into women and was going to run off with my best friend.

In fact I did become closer to my women friends. I felt a sisterhood that I hadn't experienced so deeply before. I knew that for romance I would have to keep the space for a lovely man in my life. But I loved my new kinship with women, which gave me such strength and understanding.

I also heard stories that I had been unfaithful with many men throughout the marriage. This lie was particularly painful because, in my mind, our marriage had been a noble union. I remember that, even in my dreams, it was always my husband I was with on the deepest level. To be cast out and demonized was so deeply painful and disorienting that I felt myself teetering on the edge of solitary madness.

Except for a few friends from childhood who stayed by my side and loved me through it, I had only myself to fall back on. The intense beauty of that time, the deepening sense of my spiritual life, sometimes became lost in the torment of my fear. I wondered what would become of me, alone in the world. It occurred to me that perhaps I should stay married just in case I might someday need someone to take care of me. But, I thought, what kind of marriage would that be, based mainly on insecurity or desire for comfort. I felt it would be settling for less — both for me and for him.

I began to more closely examine other marriages. I saw varying degrees of dysfunction and only rarely what appeared to me to be a truly happy, mutually fulfilling union. Relationship offers us the opportunity to grow. To be loved is to be accepted in your entirety. Basking in the love of another is to be invited to discover and become your complete self. It is a *pas de deux*, a dance of self and other. It requires a deep level of trust and intimacy to love and be loved — trust and intimacy in oneself as well as the other. For the love to flower and sustain, each person must be open to the continuous flow of self-discovery.

dance of a thousand
questions

What I was seeing in many long-lasting marriages was the silent statement, "You be that way and I'll be this way so that we can stay safely joined together forever." To me this is a state of UNholy matrimony. Unholy because in order to change our world, which is why we exist in the first place, each of us must be able to change and grow into our fullest human potential. Only then will we express the ever-new joy of our existence.

I also saw some long-lasting marriages that had not settled for less. Sometimes one partner heard the call to authenticity and, reaching out a hand, pulled the other kicking and screaming toward a more real and sustainable partnership. It's damned scary giving up your ego identity in order to allow yourself to change! The fierce struggle to stay alive and awake to self while at the same time compassionate and open to the other is the glorious dance of love. To participate takes great courage. Dancing alone is easier. But taking the journey toward wholeness with another person is what we yearn for. The beauty of it is that there is someone (besides the cat) to share a glass of wine and conversation with at the end of the day.

Unconsciously perhaps, people sometimes seek love affairs in order to find some semblance of their potential as vibrant human beings — to rediscover the self who has been left behind in order to make the marriage work. Many times it is as if the marriage is too big to fail, too important for the children, for the career, or for social standing. Or perhaps it is more comfortable to rest for the long haul with a partner who doesn't really want intimacy in a relationship and seek deeper union with another outside the marriage.

Personal transformation is unsettling to those around us. So we stay stuck in the masquerade in order to please others — or so we think. The unfortunate thing in staying together for the children is that they see through the façade even though they may never directly express it. Sadly, the cycle continues when the children's future relation-

ships exhibit the same dynamics of dishonesty and codependency as they grew accustomed to in their parents' marriage. Although painful for everyone, honesty creates a more wholesome outcome.

My former husband, the father of my beautiful children, is, this many years later, as he was in the beginning, a true and good friend of mine. We went through a period of intense anger and blame, which was hell for all of us. Then one day we went to lunch and declared a truce. It was almost that simple. We still cared deeply for one another. All the desperate struggle and pain he went through to get to that point gives some idea of the spiritual stature of this beautiful man.

Nowadays we still sometimes collaborate professionally out of mutual respect, both as people and as artists. I am so glad we married. I am also glad for the evolution of our love, which has come to include others, extending and enriching our family. A few years after he had met a lovely woman who was raising her children on her own, they invited me for Easter. At the party, her octogenarian mother said to me, "Thank you for releasing him. I don't know what my daughter would have done without him!"

I awoke this morning with the most wonderful idea in my mind. It was that when I lay dying I will look back on each person I've known in my life and see in them a rich luminosity of spirit—the divine actor behind the role they play—and I will love them. So, I thought, why wait? Why not love them now? In looking back, I see how much I still love those involved in my journey, those who were good to me and those who were mean. We did the best we could at the time. And I am happy that if I chance to encounter my former husband and his partner, I am truly glad to see them. It's like meeting good old friends.

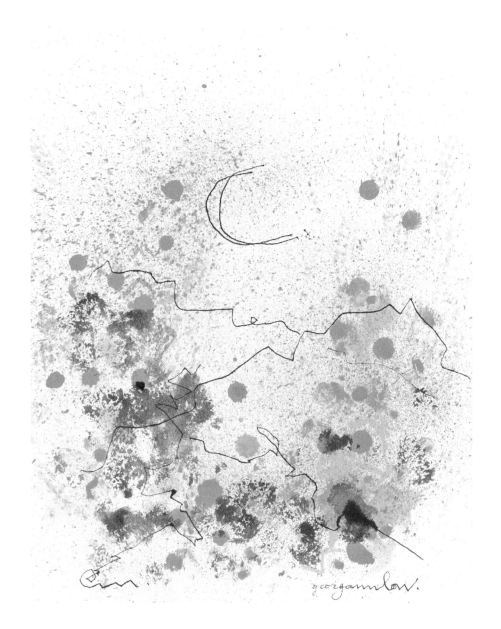

The Song

I am a weaver. I am weaving all these writings,
these moments of the past, into the fabric of now.
Sometimes I can't stand it!
It makes my head spin till I'm lost and floating in a miasma of
thoughts somewhere beyond my body.
That's when the dust and crumbs call to me,
and I cannot resist abandoning my writing to sweep the floors
— anything tangible and present!
But even while I'm doing all this
(for in sweeping the floor, I happen to notice the pile of clothes
calling to me and the plant crying out for water),
I'm somewhere else, abstracted and with a sense of urgency:
Exactly how will I weave these words?
I get into such a state that I have to come swimming back
to my little yoga mat and my meditation cushion.

Ahhhh — back to the silence.
I catch up with myself and, in letting go of my thoughts,
I find a thread of clarity.

I have written myself into a new chapter, a new life. At this point, I close the thin filmy curtain on what went before. Memories filter through, of course, but mostly I am here in an astonishing new world. The changes I've struggled through are ghosts of another self. I myself am as fresh and newly awakened as a garden in spring.

I would call this new land a paradise except that, as before, I must continue to sharpen the blade of my sword for mortal combat against my own demons. (Ever new joy, ever more demons!) I can see that it will probably not end till I'm dead, if then.

Yet I am reborn. In the newness of my vision, I write my life as it unfolds, the everyday experiences, prosaic yet profound, of simply being.

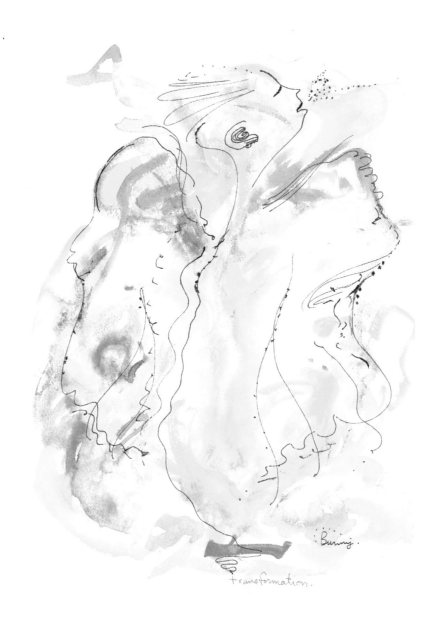

transformation.

Part Two

Dancing Alone.

Le Mont St. Michel
early morning

Sleeping and sleeping as the train descends from Paris into southern France. Nodding off, slightly nervous that I might already have missed Brive-la-Gaillarde and am on my way to Toulouse or somewhere — almost too sleepy to care.

Then suddenly I open my eyes long enough to see that I'm down deep in river country, hilly and thick with trees of the most glorious autumn colors.

I'm awake now — and ecstatic to be here!

Now there is something vibrant and alive in me, and I welcome it. I cherish it. France is completing this awakening. Confused though I may be — so many new emotions I've not allowed myself to feel before — I've grown much larger and I feel a new sensuality, also a more intimate connection with the rest of the world. Other people are closer to me — all my brothers and sisters.

Maybe all this is helping me let go of some ancient judgments about the world around me.

Somehow life's not as simple as it was — as if I'm trading my innocence (and sense of security!) for knowledge, wisdom and compassion. As I loosen my own rigid moral girdle, I slip out of judgment and into to my deeper humanity.

As we descend through France, *la France profonde*, it is so gloriously beautiful — the sun poking through the clouds, villages so small and graceful, old tumbledown stone barns with red-tiled roofs, cheerful gardens and fields of sheep … but we are in Limoges now. We stop and let the surly-faced old woman off, the one who had stared at me suspiciously when I got up to go to the toilet. I guess it must be around one in the afternoon. Of course, I forgot my watch, but I brought everything else I could possibly fit in. God! I must learn not to travel so heavy!

The desire to be alone to contemplate my partnership with the Creative is what took me to France around the time of my divorce. My father had died, leaving me an unexpected inheritance, so I decided to follow my dream of speaking French, which had been inspired by a trip to Europe when I was twelve. In that month of travel, my eyes were opened in a new way. Nose pressed to the car window, I was thrilled at the sight of actual castles and imaginary knights in shining armor galloping over the distant hills. Sometimes I was the maiden in distress and sometimes the queen. Or in one of the many storybook villages we passed, I saw myself living happily with my many children in a sweet, flower-covered cottage. In Paris, the sounds of the language sang to me of a tantalizing world I somehow recognized and longed to fully know. The seed had been planted.

When I returned to America, I noticed that things no longer looked quite right. The architecture seemed all plumb straight and perfect and boring and new. Where were the round, pointy-topped towers, their archers' slits giving them spirit faces? Where were the winding cobblestone streets and the market squares? Where were the ancient building stones whispering stories of other times? For me there was absolutely nothing romantic about a tidy bungalow in Denver!

I still loved my America. Loved the Fourth of July and roaming freely in my little town surrounded by mountains. On weekends I could ride my horse to the Indian cave and weave some wild adventure there. But being back in the gray halls of school on Monday morning, I had to march to a different drum or no drum at all, just a dull monotone. There was a certain sameness in the houses and buildings — and the people, too. I began to ache for life's poetry.

France seemed to be more the domain of my romantic imaginings — the concurrent world that flowed along under the everyday surface. In a certain sense, it had felt more

like my true home. In some deep place in my soul, I longed to return there. And I had an inkling that one day perhaps I would find a way to fully inhabit that world.

And many years later, I would. I set out to buy a little house in southern France, which would delight my soul and satisfy my passion for history. I had a vision of digging in the French earth, touching the soil with my hands, feeling the presence of those who had come before me. And when I found it, my little house, it was a *coup de coeur;* my heart knew it was my place!

It had been in the Sainte-Marie family for a few hundred years in a tiny hamlet high on the spine of a hill in the foothills of the Massif Central. It was waiting for me. It loved me with all its beautiful stone hearth. In its silent witness to ages of life lived in its sweet interior, I felt listened to and sustained.

Being unknown in a foreign place is at once frightening and liberating. I had vast stretches of time to read things like Jack Kornfield's *The Path with Heart,* a book my daughter had given me, Chogyam Trungpa's *Training the Mind and Cultivating Loving-Kindness,* and Thomas Merton's *Seeds of Contemplation.* I reread my old faves — the Brontës, George Eliot, Elizabeth Gaskell, Charles Dickens — finding comfort in the heroines who had shaped me as a young girl. They assuaged my loneliness, while my large stack of murder mysteries gave me easy escape.

Daily I climbed up the ladder and meditated in my *grenier,* the attic under the roof where they used to store the grain. There, next to my yoga mat, I created a little altar where I placed a small stone from the Colorado mountains, some frankincense, and a candle in an antique enamel holder (a gift from the house). I kept three pennies there and threw the I Ching daily, seeking perspective on my ever-changing inner landscape.

I still thought I was going crazy but figured this process was somehow necessary. "You hafta get crooked before you can get straight." I remember some stoner saying that to me back in the sixties in San Francisco.

I danced a lot to French radio stations, moving around my house, dipping and swirling on the tattered Oriental carpet, arms lifted, giving and receiving cosmic energy. I would stop and just breathe and wait — wait for my quiet inner voice to speak to me, to guide my thoughts and movement. I wrote and made drawings at all hours of the day and night. Once, I listened to John Coltrane's magnificent saxophone poetry, *A Love Supreme*, in its entirety seven or eight times in a row because it made me feel connected to other beings who had been where I was. I was still trying to decide if it was really OK to *be* myself in the world.

In the little town where I grew up I was usually considered a wild child. I was referred to as "different," which struck me as not so bad when compared with what I saw around me. It always seemed that there was a strong unspoken message to say and do pretty much what was expected, which kept things kind of flat and uninteresting. I felt the urge to shake things up a bit.

One trick I liked a lot was to climb into the Goodwill box on a corner of Main Street and make weird birdlike calls when I heard people pass by. If I was lucky enough to be in there when someone made a donation, I'd thank them profusely in a plaintive, beggarly voice. This was my first foray into street theater, and I liked amusing my friends who were watching from across the street (the same friends who stood by me forty years later when I went through my divorce).

When I was bored, sometimes I would make up a little dance on the spot—a sort of goofy tap dance. I guess it was some kind of statement. Besides, I liked seeing people smile.

I made up outrageous things just to see if I could get people to believe me — like telling the school librarian that my grandfather had known Dewey Decimal. I have trouble remembering the exact things I said, because they would pop out in the middle of a conversation that had ceased to interest me. But I do remember using my creativity to try to get myself out of scrapes at school: My mother was traveling in China and wouldn't be making it to the teacher conference. The closet in my room had burned, destroying all my clothes except for this one very short Hawaiian muumuu I'd been forced to wear to school.

No one in my family had ever been encouraged to be an artist or a musician. There was talent but it was expected to be sublimated to the pursuit of abundance. Music was appreciated, but livelihood was more important. And combining the two was far too risky.

One great uncle on the German side was both a chemist and a gifted violinist. I only saw him once or twice, but he seemed kind of an odd duck. And kind of sad. The story was that he tried to run away to New York to follow his passion for music. His father went after him and brought him back to Denver and locked him in the laboratory, where he was needed to produce perfumes and pomades for the family business. That was the end of that.

I tried taking piano lessons but found them utterly boring. They were in the late afternoon, and after a listless lesson, my teacher — a sharp-tongued, bossy sort of person — had me peel carrots and potatoes in her kitchen as we waited for my mom to show up. There was one series of art classes that I remember. It seemed slightly promising to me, although, for some bizarre reason, we were working with oils, which I've never much liked. Compared with a pen or pencil, the brush was awkward in my hand. I painstakingly painted some ugly, stilted palm trees around some sort of pond. The class was held at

the Denver Art Museum, and since it was a long drive in rush hour traffic, my mother and I decided not to pursue it beyond the first series.

My art classes in school, ranging from first grade through high school, were mostly disappointing. If I tried to make the careful, pretty pictures that everyone admired I seemed to lose any little joy that came through my heart and imagination and into my fingers — that sensation of moving the pen around on the paper and surprising myself with what happens. The delight disappeared when I tried too hard or tried to be like others.

The art teacher at school was an extremely annoying little creature who would take the pen out of my hand and make the lines she wanted to see on my drawing. One time I pushed her away, almost knocking her over. Fortunately for me she seemed to accept my phony apology!

Dying to find myself in the greater world, I left town the morning after my high-school graduation.

It was helpful, I think, to work through my changes in a place of such extraordinary beauty and strangeness. France was the world of my imagination. In this ever-changing land-scape of limitless possibility, there was no reason to whittle myself down to a predictable size in order to please others.

In France no one knew me. At first I felt like a seed hidden in fertile soil. I could feel myself changing. What I would become was a thrilling mystery.

Though the French can be very conservative, ingrained in their culture is a deep respect for the creative spirit. My art, my very being, began to make sense to me in this new context.

Being unknown in a foreign place is at once frightening and liberating. I reread Carl Jung's, *Memories, Dreams, Reflections,* a book that had "jumped" into my hands from a junkie's bookcase when I was living on the Lower East Side of Manhattan. That book had changed the direction of my life, because his was a voice I recognized and trusted. A photo of Jung reminded me of someone whose living face I had once seen in that limbic space between waking and sleeping. Now, weeping as I read, I began to understand that I could believe in that other world I had always known but only begun to take seriously.

I remember one rainy morning in France when Monsieur Fuite, the plumber, put down his wrench to look at me quizzically. "Madame," he asked, "why would a woman without a husband come to live here?" I explained as best I could in my halting French that, indeed, this was not a big deal for an American woman! He just shook his head and went back to working on the kitchen faucet.

That first summer, I singlehandedly tore down the hideous TV antenna attached to the side of my house. On this seventeenth-century stone dwelling, it was an abomination.

Besides, I did not want a television. I preferred to hear myself think. Triumphantly, I slung the ungainly metal 'multi-cross' on my shoulder and, feeling a little Christ-like, struggled up the road to the dumpster.

As I passed by the *mairie,* the town hall, to my utter astonishment I saw what appeared to be the whole hamlet gathered around tables in the courtyard next to the road, their glasses lifted in suspended animation as if proposing a toast. All heads turned to look as I lumbered by, filthy and sweating in my jeans and t-shirt and trying like hell to pretend that this was just business as usual. *"C'est l'Americaine,"* I heard someone say. And, in the silence that followed, only the scraping of aluminum against asphalt could be heard.

I became friends first with the spirits of my ancient house and garden and then, *petit à petit,* with my warm-hearted French neighbors, who gave me food from their gardens, eggs from their chickens, and who, as they spoke only French, patiently listened to me struggle with their language. Mostly, they allowed me my space to root around out-doors, practicing French with my plants. I know they were a little nonplussed when, once in a while walking past my garden wall, they'd catch me at it or even see me doing a little dance in the magic circle I'd created by my ancient linden tree. Once, a farmer heard me singing to his cows as I ambled along a country road. He smiled and said, "Merci, Madame." Oh! I dearly love the French!

Q U E R C Y J O U R N A L S : 2003

I sit watching the swallows circle from the little balcony of my house. The sun is beginning to lower, and yet the sky is that light summer blue, fragile as porcelain. I am so quiet that I can hear the echoes of birdsong far away. I always think at a time like this that birds create a sort of net of communication over the earth, taking what is expressed in this moment, in this place, and relaying it on and on until this vast network covers the whole world. I become aware that it is particularly important at these moments to send some extra positive thoughts or prayers out into the world.

Later a glass of rosé shared with silence. I feel complete, as if I were deep in conversation with someone who loves me and hears what I have to say. The feeling of communion with another is communion with Self. For the moment, there is no longing. Yet I remember what my grandmother, Nonie, used to say to me when I was scared to climb the stairs in her big house in Pueblo. She'd tell me to hold the Lord's hand. I'd say, "But I want someone with skin on him!"

So there it is — the longing for someone with "skin on him" — especially when the doves circle over my garden, flying in perfect tandem, the two of them. My friend says doves mate for life. Why didn't I? And I open the baggage yet again — but oh so quickly this time, because I know precisely what is in there.

And the question remains: Could I have someone in my life and still speak to my silent world?

La Maison
de la
vieille.
Sadirat
'02

I've been tending my garden, adding flowers here, pulling weeds there. I like to simply sit and gaze at the movement of colors and shapes, watching how the trees and bushes dance in the gentle breezes. It's like gazing at the most beautiful canvas on Earth, like that enormous Kandinsky I almost prostrated myself in front of at MoMA. It took my breath from me and left me in this deep stillness sans movement, the way I am at this moment with my garden.

The desire for beauty drives me to punish my body with passionate, heedless gardening — bending at strange angles to grab that unsightly weed behind the hostas. No one would notice it but me, I'm pretty sure, but nevertheless … I give every ounce of energy to making my garden sing. I pull and dig and do hand-to-hand combat with a particularly deep-rooted weed that threatens my newly planted coreopsis and marigolds. As I carefully pull it out by its deepest tap root, I feel as if I'm ridding my psyche of some negative, disagreeable thing.

As I write this, I hear the sound of Monsieur Flouve's tractor. He is my neighbor, a farmer, and his name has to do with springtime. He and his wife keep all the shutters on their large farmhouse closed to the world, closed to spring. It's mighty odd. They have a grown son named Bruno, who lives with them. He too is a farmer *and* he is a pervert. I know this to be a fact because a few nights ago, around midnight, he threw his underpants through my open window and then suddenly appeared at my front door!

Heart racing, body shaking I yelled at him, *"DÉGAGE-TOI! DÉGAGE-TOI!* — GET OUT OF HERE!" Then I screamed bloody murder like they do in Hollywood movies. His leering grin changed to disbelief. Finger to lips, he shushed me and looked over his shoulder. Then he backed away and ran off. Lights went on in all my neighbors' houses, and Henri, who lives in the little house across my garden, came over to see if I was all right. "It's just Bruno," he told me. "That's the way he is."

The next day Bruno, on a rampage, drove his forklift into Henri's car, smashing the front end. (Over the years, the two of them had had an ongoing dispute about a tiny sliver of Henri's driveway, which Bruno insisted was his.) The gendarmes came and hauled him off to the local mental hospital for his umpteenth extended visit for "observation" and to get him back on his meds. Trouble in Paradise? *Non, c'est comme ça.* After so many centuries of inbreeding, it's pretty much just life as usual in these little villages in rural France.

06/08/06

As I watch the gray clouds shape-shifting over the distant hills, sometimes a patch of sunlight—so delicious and inviting—gives me an image of a possible future. My interior smile brings to mind the same sort of smile I saw from time to time on my mother's face when, in spite of dark times, she would heed the voice of the universe telling her everything would work out fine in the end. "Just keep a good thought," she'd say to me. Come to think of it, though she was suffering terribly, I glimpsed that smile on her beautiful face as she lay dying.

My mother was an elegant and sensitive woman. She was funny and imaginative and she loved to lose herself in her books. When we went on trips she would tell us the stories of the places we visited. I can see her now in Italy, talking about the Medici as if they were personal friends of hers.

She was the most compassionate person I've ever known. She adored Native American culture, and I remember being awakened late one night by my father and mother arguing as they returned from a dinner party. I can still hear the passion in my mother's voice.

I found out next day that she had been defending "her" people, the Indians, against the blatant bigotry of a man at the party. My mom—with her knowledge and the intensity of her feeling—fiercely shot him down, and the party ended on a sour note. She must have been driven out of her mind by what the guy was saying, because social niceties were extremely important to her. My dad, though secretly proud of her, was embarrassed.

I have most of my mom's Indian jewelry. I feel her energy in it and I wear it to channel her presence. Right after she died, she "told" me not to grieve for her, that she was light and free of her suffering, while I was still in the struggle. It was a very clear and direct communication, as if I could see myself from where she was. I feel her love even now as I think of it.

Sitting in the glow of the early-morning sun with my tea and toast, I gaze at my garden. Fresh breezes energize the day. I am learning how to welcome happiness into my life, to turn away from frequent observation of pain. I think it's always there — the pain — lurking just behind the daisies. One must be very attentive to notice that ugly weed, which would gladly grow and spread its seed and destroy the beauty. I don't have to crouch down and spend time analyzing that particular weed, thinking so much about it that I become distracted from seeing the lovely daisies that also grow there in abundance. I simply yank it out by the roots and then wander over to another corner of my garden to see what needs pruning or deadheading in order to thrive. That's how we create and nurture our gardens of thoughts — our inner landscapes — lest the weeds of despair crowd out the beauty.

But sometimes pain is unavoidable. I came face to face with a deeply buried wound one night in a Paris hotel. Finding myself utterly alone and afraid, I made a conscious decision to allow what was lurking beneath the feelings to burble up to the surface. I had to breathe to allow this opening to happen. It felt like I was giving birth to some awful, sweaty mass of unhappiness that I did not want to see, that I had NEVER wanted to see. As I allowed the pain to swell, my cries were to my father. "Why did you abandon me?"

We were very close, my dad and I, when I was a kid. Every fall, I got to go with him on business trips to big cities, where I read a lot and ate wonderful food. My parents thought travel was as enriching as classes. My sis preferred to stay home.

And in the summer, wearing a pair of khaki overalls on which my mom had sewn a large red number 3, along with decals of his sports-car racing team, I was part of my dad's pit crew. I watched his Jaguar XK 120 circle the track time after time till he stopped and I'd give him a drink of water.

I adored my dad. We were buddies until we returned from Europe and I began middle school, when I began to become my own person. Gradually I could see that being Daddy's girl meant that I'd have to act the way Daddy wanted me to act, think the way Daddy wanted me to think. The more I changed, the more he withdrew, shaking his head sadly as if I'd died to all that was good and clean and American.

I pretended not to care. But at the same time, I was deeply hurt and angry. It hurt so much that I shoved it down deep until that night in Paris.

Dissolved by so much crying, I watched the day begin to emerge over the city and worried slightly about the people in the room next to me. Then I slept deeply for a short time and got up to catch the train to Chartres, where I spent a glorious day in a kind of raw, openhearted ecstasy. I felt cleansed and light. I splashed holy water on my head and I walked the labyrinth, moving ever closer to my own center. The enormous cathedral was a sacred space to me. I was not a tourist but a participant in ancient mysteries. I felt embraced. I felt the healing presence of God.

Now in the warm sunlight of this beautiful morning in southern France, on my hill, in my garden, my old car is parked by the side of the road. I feel as if I could get in, and like a valiant trusty steed, it will take me anywhere I want to go along these sun-dappled roads. Or I can stay put and while away the day, dreaming on my balcony. Thank goodness I have my wash to hang out! Otherwise I might spend all my time wandering the endless maze of my mind.

How exciting! The phone is ringing and, of course, it's for me! It's my new friend, Anne Marie, inviting me over for roast leg of lamb this evening. Ah, *la vie est belle.*

Lost in watching the shapes and forms of my tender garden sometimes for a while, no thought arises — only the music of the birds and the occasional rhythms of the French language. Then I begin to wonder about the raptor, golden with wide-spread wings, who flew up from the valley and over my yard this morning. His momentary presence was like a visitation from another world. It felt like a blessing to my heart. But then, my heart is constantly blessed in this place of such deep silence. I wish everyone had a place like this to simply sit and breathe in healing stillness.

And I think of meditation, which I am pushing off till later in the day, as I experiment with writing first thing every morning. It has been many years since I began meditating. I think I was around twenty-eight and living in Santa Fe, New Mexico. I paid some money to a lovely hippie guy named Strider and learned a meditation technique — a mantra to focus

my attention. I remember how difficult it was in the beginning to establish the discipline of sitting each morning. In fact, I thought I'd go nuts just sitting still and doing nothing, trying to quiet my reeling, scattered mind. Sometimes I'd cry, feeling like I was sinking into a terrifying abyss of nothingness. I thought I might die sitting so still.

But I was committed to the practice because my life depended on it. I had worked myself into a very unhappy and confusing dead end in my life. Rubbed raw and turned inside out by Haight-Ashbury, I wasn't exactly sure which planet I belonged to or if I should exist at all! I could see no way out except to stop and face myself, to sit and to listen through all the dark ramblings of my thoughts and imaginings. I sensed the possibility of light ahead.

In the late sixties, I was too stoned to talk much. I was living in some alternate reality, which as I remember had something to do with *The Tibetan Book of the Dead* and the Virgin Mary. I'm still not clear about it all. It seemed like people kind of moved me from place to place, from scene to scene, and I would mostly just sit silently and observe.

What a fabulous, magical world it was. Well, fabulous and also utterly frightening and bewildering for a kid in her twenties. There was no way I could handle the "doors of perception" bursting open like that. There was no ground under my feet. I was free floating in a strange reality which merged visions of past and future. And I began to notice that

I could read people's minds, which was horribly disconcerting when they were saying something entirely different from what they were thinking. It seemed that I was seeing through actors' masks.

One time, in Haight Ashbury, I climbed out the window of a Victorian house I was living in and somehow crawled up onto the steep roof to find baby birds in a nest, which I had intuitively known would be nestled there under a gable. I just looked at them. It was such a thrilling personal joy to see the nest and to discover that, although I had no trusted connection with other people, I was essentially with myself and could trust that. In the faraway land where I was floating, I had found a life preserver.

A window of that same house looked down on a little park. One day I glimpsed an old couple sitting there on a bench and felt somehow compelled to run down and give them each a kiss. I remember having a friendly, if disjointed, conversation with those astonished but kindly beings. I thought perhaps the entire city of San Francisco was on LSD.

And the music. Oh my God , the music — the BANDS. I was living with musicians who were playing night and day. Since I couldn't speak, the only way I could express my self was through dance, free movement bubbling up through my body. I could just be sitting there or asleep in some bed or other and suddenly jump up, feeling the energy streaming through me. I'd dance into the room where the everlasting party was happening, and I'd shake and move and for once feel totally in sync with what was going on.

Once, at a love-in, the blue sky cracked open, filled with colors and marvelous, feathery geometric shapes, and I found myself dancing wildly, like an ancient Indian spirit, with someone I'd never seen before — some other unsuspecting hippie at the mercy of the times. We stopped as suddenly as we had started and continued walking in our separate directions, never looking back.

I found I could also communicate sexually because I didn't have to use words. I had been a late bloomer. I didn't really have sex until I was maybe 18, and then only because I was sick of being a virgin. I was terrified of my own sexuality, even though as a little kid I remember messing around with the boy across the alley, whose name was Jimmy. We examined each other's bodies closely and watched each other pee in a corner of the garage. I remember feeling very turned on. But my mother found out and scared the hell out of me, told me I was bad, bad, bad, so Jimmy and I rarely "played nasty" after that.

Thinking about this, another memory emerges. I vaguely see myself as a very little girl standing in the basement room of a bald man named Izzy, who lived down the block. I remember him showing me a glow-in-the-dark tie with a dancing girl on it who moved enchantingly as he took deep breaths. That's all that comes to me even though I've tried many times to remember what happened after that. I have my suspicions because around the same time (I think I was around four), I remember lying on the floor of my living room showing my sister how I could slowly move my pelvis up and down, showing her how good it felt. She, of course, ran and got my mother, who told me to stop. I got the message that only really bad people did that sort of thing! (I did manage once to squirt Izzy in the face with my squirt gun and run away, which really pissed him off!)

Once I started getting stoned, there was no holding back. I made love all across the country in a remarkable number of places and positions, including a couple of orgies! It's just what we did in those days.

The funny thing was that my sort of orgasms were generally disappointing, never what I had hoped for. I knew the real thing existed, because I'd read Henry Miller and Anaïs Nin. And I'd read *Lady Chatterley's Lover*. I didn't have a real orgasm until I fell in love with my husband.

One person I was able to talk to because he patiently reached through my paranoia and drew me out, was a Black guy named Andy. I was living for a while in Laurel Canyon in LA, and he was a musician. During a whole day spent walking the city together, we talked of many things, including race. He was from Watts, and since I'd heard about the Watts riots I talked him into taking me there. I saw the burned-out buildings and the angry, hopeless faces. I was shocked into seeing a world beyond myself.

As he talked about what had happened I felt so strange, like I was from another planet. In Golden, Colorado, there was exactly one African American, and she was a cook. I used to like hanging around in the kitchen of the house where she worked for friends of my parents, asking her about her life. She didn't tell me a whole lot, but she was such a gorgeous human being! She had a beautiful, warm, embracing spirit. I felt so much love from her. We all did. But I was pretty damned clueless about racial issues.

Andy and I pooled our money and went to a fried-chicken restaurant. I can remember how hungry I was and how good the food tasted.

I don't know exactly how it happened but I lost track of Andy after that. I have an image of him now, much older, wearing a "Black Lives Matter" t-shirt and wondering why the hell it is taking America so long to evolve!

Thanks, Andy, for your friendship.

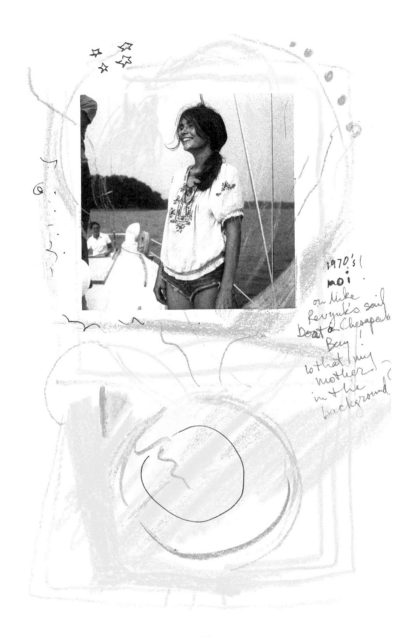

1970's!
moi
on Mike
Revyuk's sail
boat a Chesapeake
Bay!
is that my
mother
in the
background?

Sometimes I wish I could go back and visit some of those people from my hippie days, the days when I was too stoned to talk. They were mighty interesting people, especially the ones in Northern California, who were the most amazing teachers. I'm not sure but I doubt they were conventional teachers — "professors" — but they were teaching me things I was vitally interested in. Those were the days when, if you were seeking Truth, you dropped out of university. At least that's how I saw it.

What these people were teaching was way beyond books and codified learning systems. It was spiritual. It was psychological. It was the deeper realities of art, poetry, and music being communicated through direct flashes of intelligence from one brain to another. Direct perception. Crazy wisdom.

I found myself in many all-night soirées, totally captivated by the music and conversation. The people I was hanging with were friends of Kerouac and Ginsberg and Neal Cassady.

I remember a dream I had around that time. In it Neal Cassady was playing cards with some other guys. He was flipping cards into a hat. I knew that this ultimate hip dude with the bright penetrating eyes was actually Jesus. It had to do with consciousness.

Since I was a little kid, I've had a particular relationship with Jesus. I always felt I knew him, and obviously my image of him has nothing at all to do with the sappy version Christians usually hold. To me, Jesus Christ was/is the embodiment of the oneness of all beings, the pure open heart that holds and blesses the whole universe, the darkness and the light. In order to do that he'd have to get his feet really dirty! He'd have to meet humanity where it was and is, and not just hang around with the nicey-nice people.

I moved from California to Santa Fe with a crazy violin-playing junkie whom I'd more or less married. I say that because when I finally went to divorce him I found that the marriage had never been legally recorded. Soon after we arrived, the violinist left me to go back to LA and live with a poet he admired. He took the car and most all of our stuff, leaving me with only two small books, which I've found to be very useful: *The Little History of Music* and *The Little Dictionary of Musical Terms*. I hope he never reads this, because he might come back and take those as well!

Thank heavens for the wonderful gay guys I met in Santa Fe. They came out to the rundown house I was living in on Cerrillos Road and told me they thought I could play the part of Ophelia in Tom Stoppard's, *Rosencrantz and Guildenstern Are Dead*. With that, I packed up my meager possessions and moved into town to the house of a woman named Viva, where there were lots of cats and I got fleas. It's not that I didn't suffer from the fleas, but I was so elated to be in the theater that it didn't matter so much.

Later I moved into the light booth of the theater with the director of the production I was acting in. In the mornings, bright and early, we were awakened by my wonderful friend, Magnificent Mr Maurice, also an actor, who delivered Daylight Donuts and brought us ours for free!

It was in Santa Fe that I sang publicly for the first time, a revue of Noël Coward and Cole Porter tunes. I sang with an older, very flamboyant actor. Maurice, who had designed for Bette Midler in New York, created a marvelous shimmering costume for me. And my friend Loring loaned me his feather boa. Our pianist, a protégé of Bobby Short, gave me tips on singing, like, "Listen to the pianist, for God's sake!" It was a marvelous, magical evening, and despite my inexperience, it was a great success and I was hooked.

At the same time, I kept trying to establish a meditation practice (perhaps the first self-discipline I had ever managed to muster!). I stopped taking LSD and smoking pot. I began to notice changes in the world around me. Habitual uptightness melting from my heart, I felt open like a child again. I read *The Autobiography of a Yogi* and felt that I had finally found a close spiritual friend who could explain things to me. (I still follow the teachings of Paramahansa Yogananda.) As I grew less afraid of myself, the world became more affectionate toward me.

One evening after meditating, I felt my heart break as I became acutely aware of the self-serving hypocrisy in the world — my own hypocrisy! I wept for myself and for the world. After more than thirty years of meditating I'm still on my wobbly path to enlightenment. All I can say is, some nuts are hard to crack!

This morning sitting here on my balcony with pen and notebook, I wonder if there's anything to write about. There are no big events to report, no excitement, no traumas. There is, however, that bush over there, and I wonder if it's elderberry. I'd better make damn sure before I drink its leaves in tea or concoct syrup from its gorgeous black berries, because it could be a poisonous imposter! I'll ask Jean-Pierre. Jean-Pierre is my first friend in the village. He lives up the road and has the most extraordinary garden. He is tall and very lanky and has read Kerouac. He had been, I think, a Paris intellectual of sorts, sitting around in dark hovels discussing Sartre and Camus, Roland Barthes and the like. At least I imagine he did that. Anyway, he and his sweet wife, Liliane, seem to like me and chuckle at my language faux pas. He recently told me that people like Osama Bin Laden had no sense of humor. "The world would be a better place if terrorists didn't take themselves so seriously!"

How can I simply sit and gaze for hours at my little pear tree across the mossy stone wall? It is endlessly interesting to closely watch my garden grow. Today the light is changing as the cloud cover lessens. It is as if my eyes, my heart, my breath are all one. I watch with my soul and I listen.

And I'm wondering if I am throwing those snotty little slugs far enough down the hill from my vegetable patch. I wind up and throw them just like I did when I was in fifth grade, trying to win the softball throw—the one field-day event I won two years in a row. The boys I knew had taught me to throw like a boy and it worked. But now I think about those asshole slugs gorging themselves on my lettuce, and I wonder if they couldn't be inching their way back after their long flight down the hill. Hopefully, if they're not squished, they are sufficiently stunned and will forget all about my garden. Their plump, slimy selves—disoriented, to say the least—could just as easily end up under the wheels of the occasional tractor on the lower road. Peace and Love.

Last night the waxing moon woke me at midnight, shining brightly on my pillow, and I became aware once again of my deep loneliness. I fixed myself a cup of tea and wrote:

THE ANSWERS TO THE QUESTIONS OF THE HEART
ONLY COME FROM LIVING LIFE AND FROM INTROSPECTION
IN SILENCE, TRUSTING IN THE DARKNESS OF NIGHT.

THE ANSWERS MAY NOT EXACTLY APPEAR,
BUT THE WAY IS PREPARED IN SHADOW DEEP AND DARK
AND BATHED IN SOFT, OTHERWORLDLY LIGHT
THAT IS ME SLOWING DOWN ENOUGH TO ASK FOR ITS PRESENCE.
ITS RESPONSE IS NOT LIKE A THUNDERBOLT
BUT MORE LIKE THE STIRRING OF A GENTLE BREATH
AWAKENING THE SOUL,
WHICH SEEMS TO HAVE BEEN SLEEPING.

AT SUCH TIMES, MY HEART AND BEING ARE SO FULL AND BLESSED
THAT THERE IS NO MORE STRUGGLE AGAINST LONELINESS.
I REST IN THE FULLNESS OF MY MOMENT HERE ON EARTH.

AT THE SAME TIME IT FEELS GOOD TO LET THE WORDS FLOW
LIKE STREAMS OUT INTO THE OCEAN I'VE BEEN LONGING FOR.
I CAN ONLY DESCRIBE THIS AS THE BLISS OF BEING ALONE IN THE DARK.

I walk around my garden singing or talking loudly because today I saw a snake. He was sleeping in the branches of my lavender plant. All I could think to do was to grab my phone and snap several "close-ups" and then run up the hill to show Jean-Pierre. Relaxing on the porch over afternoon coffee with Liliane, J-P was noncommittal, shrugging his shoulders and saying only that it was either a viper or a *couleuvre*. Just the sound of the words made me tremble, and I couldn't quite get which one posed a greater threat to my existence.

Seeing my discomfort, he got up and showed me exactly how he stomps though his garden so that any snakes hightail it out of there. So now I'm practicing that heavy tromping just to let any snakes know I'm coming. Rather than floating about like a fairy, I march like the Gestapo and sing loudly. (Liliane said to be careful with the singing because the snake might like it!) Oh, *mon Dieu! La vie est dangereux!*

Beyond my garden, I am meeting new friends — French, English, Dutch — even a couple of Americans. I wander the countryside in my funny old Renault, with my sketchbook and pens, until the staggering beauty of some little medieval village compels me to stop and try to capture just a fragment of a stone wall or church spire. Then I might visit the local café and hang out for a while drawing or just listening. Once in a while, I hear a couple of people speaking English and I either decide to greet them or pretend to be French and ignore them.

georgemilou.

l'église
de Sentillac

I can't take my eyes away from the small white cat who is sunning herself atop the wall in front of the pear tree. She brings this soft roundness to the dense shade there — the profusion of ferns, rosemary and English ivy, and the buddleia, its blossoms spent in the late-summer heat. I have no animal in my life now, except for these occasional feline visitors. The main cat I call Monsieur Orange, which sounds lovely in French. He hangs around, sometimes sleeping the whole morning on the cushions of my balcony chairs after his all-night gallivanting. But this little pure white one is new, and I am delighted to have her company.

I'm back to meditating first thing in the morning. For a while I was writing in the early morning with my first cup of tea. Then, meaning to meditate, I found myself instead getting caught up working in my garden or whatever else took my attention. It was an experiment in time management, which failed. If I don't meditate, I never seem to quite catch up with myself during the day. Sitting in the stillness of my garden in a state of open reflection, though pleasant, is not meditation. It is a passive state, while meditation is the conscious practice of clearing the mind.

One needs a tool in order to capture and quiet the errant mind — a way of focusing the attention on each breath, as it comes in and goes out. In the silence of the breath as it naturally slows down, one experiences renewal of body and mind. And this calm oasis within can be accessed in any and all conditions. How simple yet extraordinary that peace can be found in the midst of blaring "reality."

I find writing also gives me access to my inner self — as an observer. It's more of an ongoing inner dialogue — like having an intimate friend to discuss things with. I sometimes talk aloud to myself, at times laughing heartily at some observation. (In public I usually try to not move my lips, kind of like a ventriloquist.) I'm glad they don't burn witches

anymore; though here on this remote hill in southern France, they might, in some cases, still consider it!

Yesterday a little girl carrying a bouquet of wildflowers passed my house. She saw me and gave me a funny little wink and then danced in a circle, her curly hair bouncing in the sunlight. When her mother, grandmother and big sister caught up with her they gave me apologetic little smiles and essentially told her to "can it."

"Dis bonjour à la dame," said the mother. I curtsied to the child and said *bonjour,* but she would have none of it. Still smiling, she struck a dramatic pose with her little nose in the air, like the secret princess she knew herself to be, and danced on up the road with the rest of them clucking after her. I wondered how long her delightful spark would last, until school, family and proper society crush it. That kind of personal freedom poses a threat to anyone who has completely lost theirs! How sad it is to see people with fearful eyes dictating how we should act.

I was born with the eyes of an optimist. I see that from the framed black-and-white photo of my mother holding me as a baby. She looks soft and voluptuous, gloriously feminine even, in the tailored dress of post–World War II America. Her face and hair are softly Italian, like her mother's. Her clear, steady eyes remind me of my grandfather, a surgeon whose long-ago ancestors came to America from England and Scotland. I sit on her lap dressed in a simple white cotton frock, smiling, pleased with all I see.

This photo hangs over my meditation place. I like to be reminded of my baby self, but even more, I like seeing my mother, who always loved me.

I was the second of two daughters. My sister was aghast at my birth, as older siblings sometimes are. She asked the nurse at the hospital to take me back to wherever I'd come from. When that didn't work and I was brought home, she hauled me out of my crib and hid me in a laundry basket underneath. This was not odd behavior by any means. My appearance had shaken her world.

As I got older, we fought with each other all day long. Then at night, as we lay in bed in a kind of unspoken truce, she would make up fabulous tales based on our favorite Little Golden Book, *The Pokey Little Puppy*. Her story was called "The Pokey Little Puppy and Frassy." In her imagination, Frassy was Pokey's best friend; the two of them lived in a little house with a garden. She delighted in telling me about the plaid outfits they wore and what they ate for dinner. She was a creative storyteller and would lead the two of them on long-winded adventures during which I usually drifted off to sleep. In my mind they stopped being dogs and seemed more like my sister and me in some netherworld.

I think of my parents almost every day. Sometimes I even have conversations with them. I think they'd appreciate my life as I live it now. They'd be glad at who I've become. And my dad turned out to be my biggest fan when I began singing!

My sis and I don't often see each other these days, but we talk on the phone. She is ferociously funny! I can probably thank her for my own sense of humor.

And the Christmas cactus she gave me many years ago blooms faithfully every year.

Oops. I let the cat out of the bag! This morning I told Monsieur Verne, who lives directly across the road that I love my holly bush and that it is sacred. He looked at me funny. *"Sacre? Aux États-Unis?"* In the United States? I had to laugh as I thought of all of us Americans bowing as we passed by holly bushes here and there — praying that they would protect us and keep us spiritually attuned. He asked me if I believed in God and if I was Catholic. I said yes and no. No, I'm not Catholic, yes I "believe in God." I put it in quotes, because for me it's not a question of belief but a matter of awareness.

"God is present in all forms. Gardens, for instance."

He said, "Your garden is sacred?" I glanced at his orchard laden with fruit, the large stand of raspberries, row upon row of neatly planted vegetables waiting to be picked. And in an instant I saw it as he, along with countless generations of his ancestors, saw it — nourishment, pure and simple. Then I turned to look across the wall at my own

whimsical little garden — mostly flowers and butterfly bushes with a meaningful stone placed here and there.

"Yes, my garden is sacred."

"Then what is not sacred?"

For some reason I stopped short of saying, "You're sacred and so am I." But I did tell him that I practiced yoga and meditation, and he said that in his mind meditation was used for relaxation. I said, "Yes, and it is a way to feel the presence of the divine."

He shrugged his shoulders and, with a bright smile, handed me the basket of peaches he had been gathering and wished me good day. Because word travels in this hamlet, when I do my sun salutations outside by the linden tree, not quite hidden from passersby, my neighbors will know what I'm up to.

TONIGHT THERE ARE CATS DANCING IN MY GARDEN!
CA FAIT DU BIEN.

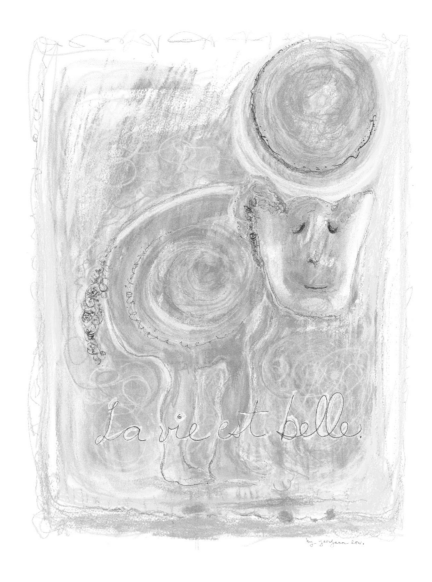

The day is moody. I awoke to rain, a lovely sound after so many hot days. There's a fresh breeze when the rain stops and the sun shines through the clouds like holy inspiration. This morning's meditation was the deepest I've had in days. Even after two months here, I'm still not on the same schedule as the French. After I do all my morning things — writing, yoga, meditation, gazing at the garden with my first cup of tea. I eat my breakfast around eleven or so and by noon, which is the Sacred Hour of Lunch here in France, I'm certainly not hungry. In fact, I'm ready for a little nap.

Last night was a night of Chinese-torture sleep deprivation. I was awakened first around one o'clock in the morning by that dreadful sound of a mosquito coming in for a landing near my ear, *under* the mosquito netting, which I keep tightly tucked around my bed each night, just in case one of those centipedes that occasionally strolls across my ceiling loses its footing and falls on my head. (I know with that many feet it is extremely unlikely, but better safe than sorry.)

When I heard the odious mosquito, I switched on the light, and spent a good twenty minutes trying to murder him. Miraculously, I was successful and settled back down after taking a few deep breaths to quiet my nerves. An hour later, I was again startled from a deep dream by a loud gnawing sound in the corner of my room. My heart racing, I switched on the light, got out from under the netting, and oh so carefully crept to the corner. Silence. There was nothing there. Nothing.

I crawled back into bed, which was showing signs of much frantic movement, like a night of intense, sustained lovemaking (if only!). Even after a few doses of Rescue Remedy, it took my poor, edgy body a while to fall back asleep. I had to talk myself out of thinking about the tapping on Edgar Allen Poe's chamber door (or was it his wall?). I could scare the crap out of myself thinking about that in the middle of the night in this three-hundred-year-old house!

Of course, within two hours, I was back on my feet, stomping and yelling— *"Assholes!"* The gnawing stopped. Complete quiet. Realizing that it might not last, I fluffed up my pillows and read a bit from *L'Armoire Magique,* C.S. Lewis in French, to see what the children were up to with Mr. and Mrs. Beaver in Narnia. I drifted from the Beavers' warm kitchen, full of the delightful fragrances of pies and good things, into sleep again.

But again, being called back from that distant land and imagining huge beaver teeth chewing a portal to the animal kingdom in the corner of my bedroom, I leapt from my bed to find … nothing. There was no sign of even the tiniest teeth marks. A few impotent hollers and some limp threats and I fell into an exhausted and fitful sleep until early dawn when it happened once more. This time I feebly tossed *The Power of Now* toward the menacing sound and rolled over.

Today, after much examination of the wash room beneath my bedroom, which is where the sound must be coming from, I've decided to go down to town and purchase a can of "mousse" to spray into any holes which could give possible access to small critters with large teeth. That is after another small nap under my mosquito net in the gracious safety of the light of day.

Louis and Simon, the mayor's sons, bring me flowers. Bored with our conversation, they root around in the cave (pronounced *cawv*) beneath my house, looking for items of interest in the pile of discarded junk. I rarely go down there, because I'm afraid of what might be lurking in the shadows. The boys are not bothered in the least, and they find an ancient umbrella, which they use to knock down cherries from my tree.

In the cave, I show them where I suspect the toad lives. I call him Bob when he sometimes visits me on my balcony in the evenings. They are fascinated and, in turn, take me up to their barn to show me Mrs. Hedgehog (Mme. Hérisson) and her tiny babies.

Since then, Louis and Simon drop by every few days after the school bus drops them off. They ask, *"Où est Bob?"* and we go looking for him. I love the way they say "Bob."

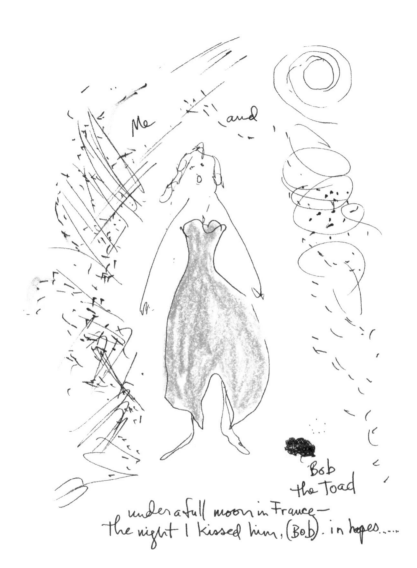

Me and

Bob
the Toad

under a full moon in France —
the night I kissed him, (Bob). in hopes......

And so my healing continues. In a phone conversation the other evening with my middle son, we were talking about this and that, but I sensed the shadows of other thoughts behind the words. There was something we really wanted to say to each other but couldn't. So I asked him point blank what was really on his mind, and bless him, he began to really communicate. And it was indeed still the old stuff, the divorce. I say "old stuff"; but when so much pain is attached to events of the past, the feelings are still fresh and immediate.

As he talked I felt his experience; I could see myself as he had seen me. It was at once physical and emotional. We were back there together, he and I, as if we had unbolted a heavy door and agreed to enter the shadowy, hidden passage beyond. As long as we stayed completely real with one another I felt us moving through the darkness with only the lamp of our courage.

The emotional space we found ourselves in was like a room in disarray, covered with cobwebs, unvisited, forgotten almost. Windows shuttered by judgment were opened one by one as we stayed there talking. Burdens of unexpressed hurt and anger lifted, light surrounding us both though we were thousands of miles apart. It is extraordinary, the power of real communication to heal the heart.

And I think about other relationships in my life, where we could not find the courage to communicate. The ego wouldn't let us. It stands as a thick-walled edifice — a construct of who we like to think we are. Safely stuck in denial and the need to be *right,* we are afraid to visit those places where deeper awareness abides. So, then, what are we left with in relationship but pretense and keeping up appearances?

I am amazed at my son's courage. He is a warrior, deeply masculine and strong, and likes to be in charge—truly a man's man—yet he is able to swim deep in the dark, murky waters of emotional memory, which is more feminine territory. And he has a beautiful heart!

My elder son went through the divorce differently. His nature is uncommonly stable. He is profoundly wise, deep and vast, like the ocean itself, and full of compassion and quiet wisdom. He moved through the sadness of the time with forgiveness. That is his power and his remarkable gift.

My daughter provides me the inspiration to live my truth and be real. She is extremely sensitive and aware, yet, when necessary, she is as fierce as a warrior. She embodies such compassion for all of us. As she matures she has begun to offer that compassion to herself as well. I simply sit back and watch this flower—this beautiful rose—unfold.

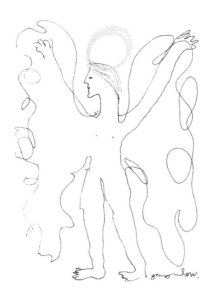

Here in my little house on the hill, I am living my deepest, most intimate story. Here the quiet, which is filled always with birdsong and distant cowbells, soothes my heart and breathes me into this benevolent moment. I am healed breathing in and out, vibrancy and delight, centered and complete before the setting sun. I am so blessed.

No computer, no TV, and, at the moment, no phone. Dinner tonight—mainly duck breast and spinach. It's what Popeye would have eaten if he'd lived in southern France. *Très puissant!* In my mind I flex my muscles like Popeye.

My pen moves the words along the page as it might in a drawing of the hills across the valley — those same *Collines du Quercy*, the hills of Quercy, I will always return to in my life and in my art. Pen and ink flow onto the paper as I allow the process of image becoming line. I am conveying information. The movement of the pen allows the lines of what I am looking at (or thinking about) to flow uninterruptedly, looping and curling and dancing onto the page — in itself a sensual act.

Words are more difficult, more painstaking, as you string them together on the page, never quite sure where they will take you (as in a drawing, as in life itself), just allowing it all to flow (wu wei, I think, is what the Taoists call it) staying in the flow moment to moment, one with the stream, sitting back a bit, relaxing and allowing. Groovy. Chuckle, chuckle. Feelin' groovy. Groovy, Man. Very satisfying not getting hung up in trying to make too much sense of it all.

I like how writing can take you off for a jaunt in your head and then set you back down in the chair where you've been all along.

But I don't actually consider myself a writer. The truth is that if I called myself a writer then I might have to get serious. Maybe I would have had to study and work toward it, devote my life to it or at least take a class in memoir writing or join a workshop — things that don't interest me in the slightest. Besides, since I don't know what the hell I'm doing, I can do whatever I please. (In my usual arrogance I prefer that.)

So this morning I have the sun on my several Peace roses in various stages of blooming here on this first day of September. Celestial yellow with pink edges, a gift of early fall. I also have the gift of wonderful Sylvain from across the valley here to help me in my garden, cutting my grasses and pruning my little fig of its dead branches till it's all so lovely that I can't stop looking at it. Knowing that I'll be here another month and a half, I wonder what in the world I will do with that immensity of time. I think of how my days in Denver were accounted for, each one more or less mapped out and programmed. Here I am happy to stay tuned to each moment — the breeze moving the leaves, feeling it on my skin, in my breath, in my heart so quiet. This is where deep sanity and health abide.

The little white cat comes near then scurries away. I will put a bowl of milk on the stair.

I'm wearing earplugs at night just in case the "mice" make noises. Even through my earplugs I heard a thud from my kitchen last night, as if something more the size of a cat had jumped down from the table. Mice are normally not as big as cats and that has me worried because I prefer to think of whoever it is as a mouse. And I'm not going to use the "r" word, the "r_t" word, because it is one of the most awful words imaginable and, frankly, it makes me shiver. Jean-Pierre recently said he thought I had a *"raaa,"* which sounds much better to me in French. In any case, the small mousetrap with a dab of peanut butter is not working.

This morning, I noticed a couple of rather large teeth marks in the skin of my melon and laughed. I was thinking how the disgruntled raaa, not being able to get at the corn chips I had covered with a bowl inside my basket, had made a half-hearted attempt at the melon. In his frustration, I imagined him throwing himself to the floor in a huff and slinking off. Oh! But where to?

Now I'll have to get serious and go to town for a raaa trap. I was so hoping to avoid all this!

I sometimes wonder who, if anyone, will ever read all this. It really doesn't matter. I could say I'm writing for my grandchildren who will come some day, but I know better. I am writing for myself. I enjoy the process because all I have to do is write the truth. I like that! I fill the vastness of this space I've been given with expressions of my experience, the truth of my inner and outer life as each moment unfolds. It so naturally happens when one has the time and space and, especially, the quiet. And it tunes in so beautifully with the rhythms of my garden continually changing around me. Those daisies along the wall are down to three bright blooms, while the hostas in the shade garden offer exotically shaped white flowers, like fireworks in the green shadows.

I met a Frenchwoman the other night at a party. She looked like a pale hothouse flower. She told me she liked to *juxtapose* (which is, in fact, a French word) — she liked to juxtapose words that don't normally go together in order to strike through the normal thinking mind. She was a poet but she told me she was afraid of going too far into her writing because, she said, she might never be able to find her way back out. She seemed like a fragile glass wind chime, easily shattered by the elements. Maybe she has a fine poetic gift to give.

Why are we afraid of ourselves? Is it the sense that we are much bigger than we have been imagining? Much bigger and deeper and more obscure, like a bottomless chasm, like the Glory Hole Mine up in the Colorado mountains, which, as a child, I refused to look into? It seems that as we gradually penetrate the layers of what appears to be frightful and unknowable, we bring light and awareness. In the fearsome underworld, we discover unexpected jewels; we make friends with the difficult and complex darkness of our natures. There is power waiting to be mined.

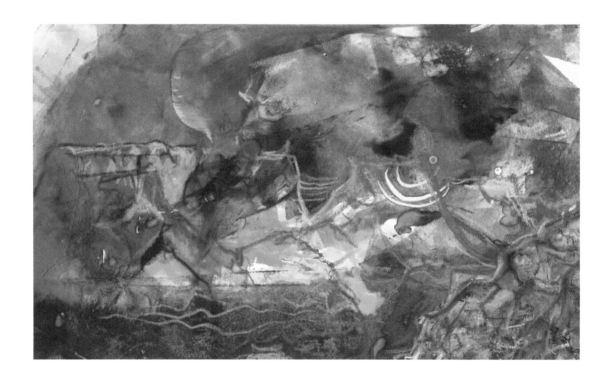

On this sun-drenched day, sitting on my balcony, alone, on the spine of this high hill, I could keep opening to deeper and deeper levels of being in my psyche. I feel as if I can dare to look at anything from this perspective, because whether you write about the mice or you write about the children, the humor or the guilt, the same birds circle overhead and the same gentle currents of air refresh your breath and your daring.

Funny that I have so much guilt associated with my children, but I do. Mostly it has to do with the times I lost my patience. I screamed at them and flew around in a witchy rage. Poor things! I can easily remember the feeling in my spine, my over-amped, over-caffeinated nervous system, as I dealt with three kids who were very close in age and very rambunctious. At the same time, my love for them was as big as the universe, and they knew it.

Sometimes I wish I could go back in time and hold each of them in my arms and kiss them. Like in my dream last night, my middle son and I were back as we'd been when he was a little boy. My heart was so wildly happy that as I chased him around and around, I found I could bounce up into the air. When I woke up there was a tear in my eye.

But then again, maybe it's like the cake — the chocolate cake I baked recently for a little dinner party. In my sunny kitchen as I was finishing the mixing I realized that, because I'm doing this here in France, I'm never quite sure about the measurements or oven temperature. (Even worse, I'd left part of the flour out!)

Asking for a small miracle, I said a little prayer that it would turn out marvelously in spite of my fumbling. When I served it for dessert all conversation stopped as each of us focused on the experience of sweet dark chocolate melting over our palates. In spite of my mistakes, it was delicious, richly complex and balanced — like my kids!

I promised myself I wouldn't forget the lesson of the cake. When I find myself slipping into realms of guilt, I will think back to that cake. It can be just that simple if I pay attention — if I catch the engine, so to speak, of a particular train of thought and notice where it's headed. Maybe it's looping back around the same bend to a desolate landscape where all the good is forgotten. I've been there far too many times. If I gently take the controls, I could branch up a different track to a new vista of possibility!

In other words, who do I think I am? In my own mind, am I worthy of real happiness? For any who seek, the answer can be found in the very quiet realm under the surface chatter of our minds. In the realm of dream and darkness, we can reclaim our true natural bliss.

But who the hell wants to work so hard when life can be lived scooting across the surface of time, attending to our agendas? Lost in habitual, unexamined thoughts, we cling to a false identity. Besides, what would people say if we changed? What if we were no longer the person they had come to expect? It's much too scary to see who we are without the precious attitudes and prejudices we think define us. Why go crazy trying to get to the bottom of our discontent? Why not simply use pharmaceuticals? We can pop some pills and hang out in no-man's-land, or purgatory, for the duration. Purgatory is an interesting concept — neither heaven nor hell. I think perhaps we must go through hell to reach heaven. And I'm not referring to an afterlife but to the here and now.

OK, so I have a small crush on my hairdresser. His name is Felix. Not Felix. Fay-leeks. And he looks like Elvis Presley. He even kind of sashays around his tiny salon like Elvis would on a stage in Vegas. No doubt he's terribly handsome, but at heart he's a healthy farm boy from these parts who speaks the patois and is gay.

The patois is not your Parisian French. It sounds more like Spanish spoken with marbles in the mouth. So Felix and I have these little dips in our communication. For instance, he asked me if I wanted the special treatment to take any yellow out of my silver hair. I had no idea what he had said so I answered in French that I didn't want it shorter but just shaped a little. He gave me the quizzical "Eh?" which I'm quite used to and, shrugging his shoulders, gave me a nice trim.

And today Sylvain is here mowing and pruning, which I find quite exciting because any little change for the better in my garden gives me great pleasure. Also because, for a short time, I felt like a lady of leisure. But twenty minutes after he'd arrived, and I'd settled into my writing chair in the *grenier,* I heard a tap-tap on the door. I descended the ladder to find cheery Sylvain, who proudly wanted to show me his trick of (I think he said) mixing gas for the mower with sunflower oil so he could save money. I told him I thought it was a very good idea, *bien sûr.* He also speaks such thick patois and, being somewhere in his early twenties, still mumbles like a teenager. I always have to guess or surmise or divine exactly what it is he's saying and usually end up making something up, which makes for bizarre conversation. Anyway, after this little lesson he picks up the various bottles he's been mixing for fuel and moves them into the shade. Then he mumbles something else, and, still in my agreeable mode, I simply smile and say, *"Oui, oui. C'est bon ça.* Yeah, that's good."

"Eh?" he says and then repeats slowly and clearly so that I can't help but understand:
"There is a dead bird next to your car. I think you ran over it."

"Mon Dieu!" I say.

"It's flat," he says, picking it up by its tail feathers and then dropping it.
"Maybe it was sick," he says shrugging his shoulders.

I say that I'll go get my "thing" and throw it down the hill. (I never can remember the word for shovel!) He says something about the smell and that I'd better bury it. Fine, I think, and go dig a small hole under my walnut tree and put the dead bird in it. Remembering the lizard funerals of my childhood, I place a small stone on top of the tiny grave and a red clover flower and that's that. Except that when I climb back up the ladder to my *grenier,* my coffee is cold and I can't find the thread of my writing. Ah, well.

There's this noisy little kitten living with me at the moment. He is on loan from some kind neighbors who say he'll keep the nighttime beasts away. So here he is, skittering around the *grenier,* climbing the wooden beams that support the roof, leaping onto tables filled with baskets of pens and watercolor crayons; papers flying everywhere, my art whirls around me. I'm living in a Tom and Jerry cartoon with cats and mice chasing each other around the house and me standing on a chair, screaming and waving my broom at them.

At least I'm sleeping better at night. The nocturnal creature is silent. I invited Monsieur Vern, who was outside my kitchen window picking apples, to take a look at the tiny poop in my *grenier*, and he told me it definitely did not come from a rat.

"It is either a *fween* or a *luare*," he says. I've never heard of either of them, but since Gérard and Mauricette Vern seem to have the answer to absolutely everything, I take his word for it. I also think he said that there are no rats in our village.

"Rats don't exist here," he says. I question that but then I'm not really sure he said it so I let it go. Besides it's very nice to think that there are no rats here. And I don't think "fweens" and "luares" sound all that menacing. Anyway, I enjoy the mighty little kitty now purring next to me in my chair.

My life is brighter than before, like the fire in the hearth as it responds to the breath of the bellows. There is this clarity that comes from the quiet and abides through the changes of each day like a current of sanity flowing through the vicissitudes of mind. No matter what happens I return always to an inner hospitality, as John O'Donohue calls it. This is new.

Plus, I have decided not to throw slugs down the hill like baseballs anymore. I happened upon one near my clothesline and it was horribly squashed and oozy. I felt bad. So to make up for it I'm giving them all a party. I've put a large dinner plate brimming with beer near the cabbages. What happens is the slugs climb in and their lust for beer overpowering all reason, they drink themselves silly and drown. *C'est tout!*
That's all. That's all she wrote.

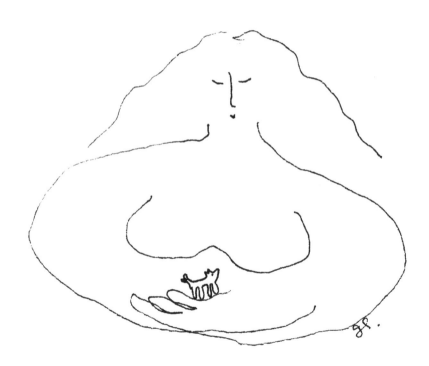

My neighbor, Mme. Flouve, passed by my garden wall yesterday carrying food scraps to the chickens up the hill. She stopped to have our usual chat about the weather and then asked when I would be going back to America. I told her not 'til mid-October. "Ahh," she said, "You are staying a long time. You are becoming 'of this place' a little bit, I think."

The clouds and mist rise from the valley below as if lifting up out of my mind. Last night I dreamed of Woody Allen. I have no idea on earth why at certain times in my life he is there in my dreams. I don't attach much importance to him in my normal waking state. But somehow, he appears in my dreams as very sober and wise. Last night we made love, which I won't describe, and then we were going to go into business together fixing up dilapidated houses and selling homemade jelly on the side. We were going to sell it to people who came to look at our properties. (This was kind of a lighthearted little Woody Allen dream; others have more to do with artistic unfoldment and my quest for personal authenticity.)

So I'm a little fogged out this morning and also a little distracted having to chase the kitty around to make sure he stays within the garden walls for now. He's feisty and funny, and I adore cats, but I will have to give him back when I leave. I move around too much, it seems, to have a permanent cat. Since he's been here I've heard no more noises in the middle of the night — only the practical down-to-earth conversations with Woody.

I've put away the Rescue Remedy and the earplugs, and I sleep like a baby. Unless, of course, a thought or fear comes pounding up out of my unconscious and awakens me. In that case, after pointlessly tossing and turning for a while, I get up and make vervain

tea and try to look squarely at what's bothering me. It's usually finances. How the hell am I going to survive? I will undoubtedly outlast my money unless I can make more. *"Gagner ma propre vie,"* as the French say. Make my own living and stop relying on my ancestors! I've already jumped in with both feet to this creative life. Now I must expend more effort or drown! Eventually, I turn over and go back to sleep. I dream of the ancient linden tree, guardian of my garden, who's been struck three times by lightning yet still blooms.

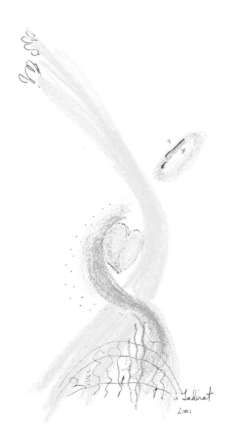

This morning on Radio France Musique, I heard this wonderful program about Thelonious Monk. It began with a pianist discussing and playing Monk's very particular approach to chord structure. Then they played this very funny recording of Monk with Miles Davis in which, during his solo, Monk suddenly stopped playing! The bass and drums were cruising through the changes, and Monk just stopped dead. After a very long space, Miles jumped in with his horn as if to remind Monk that he was in the middle of a solo. As if to say, "Come on, Motherfucker! What do you think you're doing?" (Miles always called people motherfucker). Monk got going again, kind of like he suddenly woke up and found himself in front of an audience and in the midst of a solo. I've certainly felt like that on stage at times!

It's so quiet that I can listen to Muddy Waters and hear every lick he plays and sings. I've been listening to this music for years but never heard it so intensely. The Mississippi River flowing through my veins nice and slow and wide and deep. What do I do with this immensity of time? I simply sit and wait for the next breath, the next thought. Rather than fill my space, I wait for it to fill me, to inform me. I begin to hear my own music in my head, and I sing tune ideas into my iPhone. I can add lyrics when I get back to Denver.

I've been looking all over the place for French musicians to sing jazz with. I even drove for a few hours in the middle of the night after sitting in with some players in a club in Cahors, losing my way in the moonlight on backcountry roads, and praying my old Renault would get me home. The music was good so it was worth it. I love French audiences! They really listen to the music, they respond to the nuances of the voice. It is like having a deep conversation where you surprise yourself at what you are able to express.

I've found two sublime French soul brothers — Freddy, who plays stand-up bass and piano (not at the same time, of course), and Jean-Louis, an artist who plays drums. We

met in J-L's studio high up in the glorious hill town of Rocamadour, a pilgrimage site on the route to Saint-Jacques-de-Compostelle, and played for several hours, pausing only once for a glass of rosé and some bread and saucisson. The whole time it was just me singing with either bass or piano and drums. If Jean-Louis left the room, Freddy and I would simply continue with bass and vocals. So spacious, so open, the two of us tuned into each other and listening so that we could take off in any direction and stay together like two birds flying high.

We are looking for gigs!

Thierry has come and fixed the hole in my roof. Now I won't wake up with rain in my bed! On this fresh autumn morning, I am considering the kitten who is purring loudly on my lap. She has turned out to be a female. Her name is either Mme. Miew Miew or Claudine, I'm not sure which. She's so adorable! Should I try and take her back to Denver or is that a little insane? Better to find someone here who will take her. Otherwise, Philippe says they will send her off into the woods if I return her. He says that they'd drive her a long way away and leave her to fend for herself. "There are too many cats in the village," he says matter of factly. I don't see this as mean. Philippe and lovely Charlotte live close to the wildness of the land. But the idea of it makes me ill because she's a "people" cat.

I love the dinner-table discussions I get into with Philippe and Charlotte. We talk about everything under the sun but we always get back to politics and social justice. We rant and rave for a good long while and usually end up laughing our heads off at the ridiculous fools running both our countries. (This was when "W" was president.)

Somehow at those times, the words come to me and I can express myself surprisingly well in French. That's because I'm totally engaged in the conversation. It's when I have to

talk about mundane stuff or describe what's wrong with my lawnmower that I fall apart. I find myself acting out in a most peculiar way the necessary words or concepts. In fact, I throw myself into it. Can you imagine acting like a lawnmower in the presence of some rather solemn French tradesman?

The first yellow leaves on my walnut tree. It is time to gather my nuts!

One pinkish red rose grows tall in the corner of my walled garden behind the rosemary plant, which I recently pruned into a nice rounded shape. The ferns are back there too, so it's lush, beautiful and, for me — coming from a high, dry climate — rather exotic. My easel is still set up there from this morning when I got all my art stuff together to stand in the shade (it's still quite hot) and work with my acrylics. I toiled there for a couple of hours working on canvas though I prefer paper because it is smooth and my beloved pen glides easily over the surface.

I really "worked" on this artsy-fartsy acrylic thing, trying to faithfully render a pot of flowers onto the canvas with a brush, until I was all tired out (and, frankly, bored) and my patch of shade had shriveled to nothing at all. I took the canvas inside and put it on the stair ladder to the *grenier*, where I like to view my art. Since I had some leftover

yellow and orangey paint on my palette, I smooshed it onto some watercolor paper on which there were colors from another palette, another time. I got so excited using my little sponge to push the colors around in interesting ways. I was excited by my sense of freedom — the oranges and yellows moving around the bit of red and the blob of Virgin Mary blue. It made my heart sing to look at it.

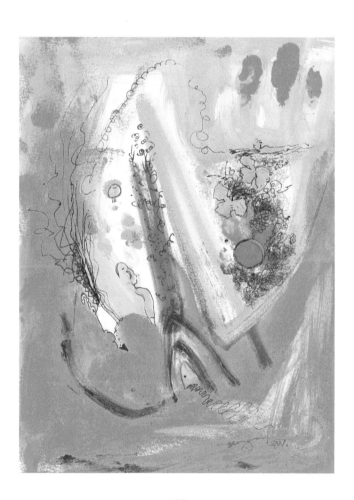

Later, as I regarded my overworked canvas of the pot of geraniums, I found it so dis-
tasteful that I had to turn it around so as not to see it. And against its backside I posed
the watercolor paper with the mélange of abstract colors and dancing shapes, which
made me so happy.

I think I will not again "work" at doing art. What's the point? I'm bored before I even fin-
ish the piece. I'm also bored when I look at what hangs in most galleries. I'm disgusted
by the sameness I see. It's logical that because I spend so much time alone, in my interior
being, that shapes and lines make more sense to me than those dabby paintings of flow-
ers and landscapes. Now I understand that for me it is the language of the unconscious
I crave. The expression of the hidden that I look for in everything — especially in art.
Otherwise I am mortally bored. (No wonder I'm alone!)

J'attends.

There are two doves on the tiled roof of Stefan's barn down the far side of my hill. They must be lovers because they've been there for at least an hour looking over the valley. Their backs were turned to each other for a while but now they're nestled in close together as the day begins to close. Again I wonder if I could have someone in my life and still speak to my silent world.

I am living a life so terribly quiet and alone these days. Reading Charlotte Brontë's *Villette* for hours on end, I begin to feel like her heroine, Lucy Snowe. She is such a solitary creature with an interiorized nature. Here in my little house in France I've become that as well. I find that I both love and hate my solitude.

Then there is the matter of my close neighbor, the poor, bereaved donkey who bellows mournfully several times a day and in the night and who tries to get next to me when I'm hanging my clothes to dry in the lower garden. As I pass close by the stone wall where I'm afraid vipers might be hiding, I sing loudly to warn them of my presence. That's when he comes trotting eagerly toward me, stopping only because of the wire that confines him to his tiny pasture.

I told him I would be his friend, but when his back was turned I tattled on him to M. Vern who owns the field. Actually, I complained to M. Vern's sister, Arlette, that he was keeping me awake at night. I knew that she herself suffers from insomnia and, since we are friends, I felt she was likely to speak to M. Vern on my behalf.

I soon realized that I was interfering with the ways of the village livestock and decided to just live with it. I even began to feel a bit of a kinship with him (the donkey), because I am told he brays because he is sad to be alone. His is the most extraordinarily long-winded and heartrending expression of loneliness! I sort of relate to it all: Brontë's Lucy Snowe

and the donkey whose name I don't know are at this moment my closest friends. But then there is also Miff Mowle, my octogenarian British saxophone friend who actually met Chet Baker once in London. He said Chet was slumped by the fireplace in a friend's flat mumbling from his heroine haze. (Who cares when you play like an angel?!)

Miff also played with Jack Bruce and Ginger Baker before they joined up with Eric Clapton to create one of my favorite albums of all time, *Fresh Cream*. I love driving down to a sunny outdoor cafe in Saint-Cere to hear about Miff's adventures playing with the likes of Count Basie and Peggy Lee as he sailed the high seas on the QE2.

I must write this morning. But not knowing what to write, do I just wait till words come onto the page — automatic writing, as it were? Or do I write about this early-morning's long and deep meditation in which, at one point, a door opened into a dark chamber. Ancient windows were thrown open to soft sunlight, and I was sitting in a high castle tower gazing out at a long-ago landscape. I felt as if a thousand years of sadness was releasing into suffused light, and I heard sweet voices. I felt light.

After I finished my writing I did a little dance to a song on the radio. A curious sort of standing-in-one-place dance on my frayed Persian carpet, turning slowly to the four directions and using my arms as if to cradle different people who came into my mind, moving even beyond my people to mankind in general. Love flowing through me, I lifted my dancing hands and called for the healing of our human heart … dissolving in tears … ahhhh bittersweet.

And now the sun is popping through the clouds, and the silent day begins to buzz. Jean-Louis just called to say that I have a gig with him and Freddie next Monday. I will earn a damn fine hundred euros!

Performing with Freddy's trio (we've added a guitar player) is a dream come true. Being there in the music on stage in the lights with these guys is like being in heaven. The communication is so immediate and absolutely truthful. The music is the goddess, and I give my heart to her completely and thereby to the people present. One can send out a lot of blessings to the world in those moments (if one remembers to!)

Sometimes it feels like the music is playing itself through the musicians. The greater mind of the band — the union of musical spirits always listening, always open — takes you in constantly changing directions. There seems to be no such thing as a separate audience at those moments. The players, especially the singer who holds the words, become a doorway through which every person present becomes part of the dynamic creativity. In a way it moves us toward the idea of cosmic consciousness. We are no longer separate entities. The union of souls is far more splendid than the individual. The music is greater than the sound of one virtuosic horn.

Ah, but alas, this morning my Renault is dead, dead, dead. But never mind, because my friend is coming to pick me up. We will spend the day chasing around this little rural corner of France, going to *vides greniers* (flea markets) to browse for dishes and to the town markets, where the produce is so fresh and colorful and the old women weave baskets and farmers wear their berets and good-humored smiles as you stop to admire their chickens. It is summer in The Lot!

Miew Miew will not be flying back to Denver with me. It was a rather short-lived fantasy, like when you were young and would fall in love very briefly, maybe for a day or two, and then wake up wondering where you'd been. And it was over just like that, as if you'd developed some kind of allergic reaction to the guy. That is precisely what's happened with kitty. There are cats with a certain kind of long hair who cause me to sneeze and wheeze and rub my eyes. Miew Miew, as she's grown, has that kind of fur.

I found this out on a day when all the windows had to be kept closed because of M. Orange. He knows he is king of all the cats in the village and has developed this sort of swaggering "biker dude" persona (catsona). During the day when he's not lazily stretched out sleeping on top of the village garbage cans, he's skulking around my yard waiting for an opportunity to steal into my house and eat kitty's food. Once or twice he has even sprayed, which is where I draw the line.

Ever since I got kitty, I feel like I'm being taken over by cats, like a coup is in progress. I thought if I just kept the door closed, he'd mosey off. But, oh no, there he was at the window — his greedy eyes triumphant, his muscles rippling, and a weird, leering smile on his face. (He sort of reminded me of my deranged neighbor!) So, I am redoubling my efforts to find Miew Miew a home. I now cannot wait to be done with this cat episode!

Of course, all this gets me thinking about me and my fantasy self. There is the "real" me and there is who I think I should be in some kind of picture-perfect world. I would always be kindness personified instead of at odds with this cat or that child of mine or that marriage. *La vie en rose,* only not really. I had some kind of stilted idea in my head about what a family should be. Was it a residue from *Leave It to Beaver* or observed from childhood role models striving always to be nice.

I let my kids be pretty outrageous and wild. Each one was extremely interesting to me. I didn't want to kill their creativity. But I expected my reaction to bad behavior to always be evenhanded and wise, which, of course, it wasn't, and that deeply upset me. Thus, it was no wonder that at the end of my marriage I could no longer find the smiley face. The shit hit the fan; the need for emotional authenticity finally crept in. Or rather, it erupted like a volcano and blew me to smithereens! It was, I think, a kind of emotional breakdown. I am certainly not going to expend that sort of energy on a *cat!* Which is one more reason I love getting older.

I am a seeker of harmony. I seek to harmonize the various manifestations and conflicts of my vast nature. In my earliest memories are the echoing sounds of hammers as Denver expanded to receive The Baby Boom. Lying in a bassinet in the garden, I felt the sun shining all around me and at the same time within me. What was outside me was inside me. Those early years were like that. I remember once sitting in a high chair in a crowded restaurant when the noise and energy around me became a vast, vibrating hum, sort of like Tibetans chanting. I was at once there and somewhere else. I was one with all. Is it any wonder that so many years later I sought oneness with all creation through drugs, knowing all along that it was only to be found naturally through meditation?

After a few days away, it's so nice to return to my garden, deeply tranquil as my soul at sunset. I am home. There is nothing to say or wish for. My heart quietly beating with the eternal rhythm of my breath. When all thought stops, I can see the earth breathe. Shhh! Don't break the spell of this magic twilight.

Luncheon (not lunch) chez Pierre et Clotilde de la Source, my neighbors a few hills away in a sixteenth-century château! I am constantly aware of my good fortune to be here in this place, meeting many new friends, speaking French or English or whatever gets it. After lunch, Clotilde and I work on a French song to sing at dinnertime for the next Tour d'Architecture all-day adventure, which starts in the early morning and usually lasts some twenty hours or so. We travel the countryside looking at little-known architectural treasures — ancient towers and churches and châteaus with wonderful gardens.

With great passion Pierre guides us along tiny, hidden roads throughout the Lot, Aveyron and along the Dordogne, until wide-eyed *et très fatigué,* we land at a storybook castle, where the tables are lavishly set for a sumptuous meal by candlelight. Along the route we meet ancient owners of ancient châteaus, some who live in shabby but proud gentility and others who can afford to live in the splendor of bygone eras. Pierre never bothers with the simply rich. It's the stories of the stone and the history of the land he seeks to show us. We've occasionally arrived unannounced at a château to find the proprietors less than eager to show us around. But the door opens wide when the charming Pierre, a sculptor by trade and a nobleman by birth, discreetly mentions his lineage.

The first time I went to Pierre and Clotilde's for dinner, the conversation was entirely in French and I couldn't keep up. I felt extremely awkward and isolated. They had invited

me because I was new to this little corner of the Lot and they had heard I was a jazz singer. When dinner was over and the cognac served, they asked me if perhaps I could sing a little something for the group. I was feeling so out of it that I embraced any opportunity to communicate with these exotic people I so deeply admired. Besides, I thought, if I call myself a singer then I should be able to sing anywhere, anytime. I stood up and sang "Les Feuilles Mortes" (the jazz standard "Autumn Leaves," only much more evocative and rich in its original French). They were so quiet and attentive that I felt as if I were communicating with each person there. Once again, music saves my life!

It reminds me of the time in New York when I sat for hours waiting to sign up for food stamps. This was a few years after my Haight-Ashbury mute days, and I got to talking with the guy next to me, an older, hip-looking Black dude. I remember saying that I was currently selling Christmas trees on the street but that I'd really like to be a jazz singer.

Later, in the course of our conversation he asked me point blank if I did drugs. I kind of hemmed and hawed and avoided is eyes. But he knew. And he told me that I was living in a bad scene with people who were addicts. But, he said, he could see that I was still fairly innocent.

"You won't be for long," he said. " If you ever want to really play music you need to get the hell out of there!"

I was dumbstruck! But I felt wide awake — more awake than usual. How could he know so much about me? In an instant I saw him as a hip-dude angel sent to instruct me, to save me. And when I asked, he told me his name was Music.

Shortly after that I moved back to Colorado.

I've found a home for kitty — a good home with Dutch artists I met through Pierre. I will take her down the winding road to the little fairy-tale house with flowers growing every-where, and I will drop her off. They will love her, I'm sure, and she will be as happy as any cat could possibly be unless, of course, she gets eaten by a badger, which is always a possibility in these parts. Try as I might, I can't seem to find perfection anywhere!

Except in my garden in the warm autumn sun. Sheltered in the three-sided ruin of a *sécherie,* where the old ones dried nuts, I sit naked and out of sight with the sun pouring down into my heart.

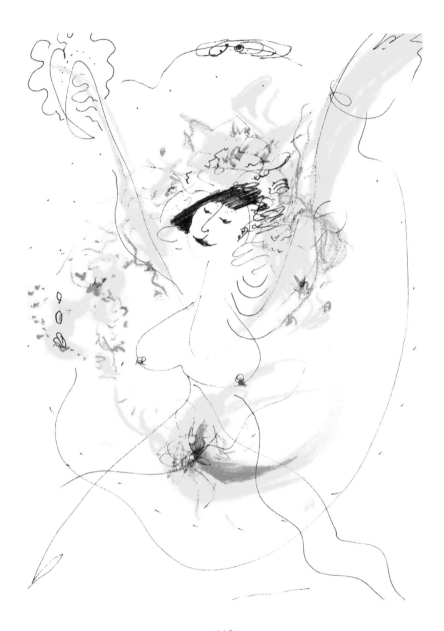

When I think of the insane pulse we all hearken to back in America, I think maybe it's a very good idea to hold sacred the lunch hour. (Here it's more like two hours!) I'm not looking forward to the rush, rush, rush of my city. Denver is generally pretty laid back but still. Boy, do we move fast over there!

By contrast, the people around here aren't that interested in making money. They work hard but they don't sacrifice their quality of life in the pursuit of cash. They give their time and their full attention to the plate and glass before them. Or to a conversation or to *les bisous* — those little air kisses they always exchange (which I usually forget), putting down whatever they're involved in to really greet you. After the sacred lunch, they take leisurely strolls up and down the road chatting away in their musical language about cows and potatoes, whereas I haul ass up to the cross at the top of the village, moving fast to burn off calories from all the cheese I've eaten!

This morning I thought, "I don't need to get out of bed. I don't have anywhere to go. Nothing to do, I might as well dream some more." I wanted to turn over and drift back into the dream I was having about the Chinese woman with her child. The woman was like me. She *was* me. I lived in her as well as in myself. Or maybe I will just call her my sister.

My "sister" is somewhat worried in China, as I am in America. The bad things happening are way beyond our control, created by people who don't see the world in its radiant light and beauty as we do. Is it because they've never been or felt like mothers? Say, for instance, the party bosses and corporate big-money guys, men (and women who act like

men) who want power and control over the rest of us, who care more about money than they do about humanity. Do they plant and nurture and love unconditionally, the way mothers do? Mother love will be the tipping point in this scary world we live in.

But then the song of a bird outside my window called to me. "Well, I could go peek at the garden through my lacy curtain and see if anything's changed. And then there's always coffee and toast!" So I find myself once more getting onto the yoga mat in the *grenier*, allowing my body to tell me how I need to move. Feeling stretched out and open, I then sit and meditate. As I quiet my mind I rediscover that sense that I am exactly where I need to be at this moment. That I will be guided. That the things I want and imagine having in my life, including peace in the world, may or may not arrive in due time. But I will tend my garden and do my work without so much struggle and ambition, desire and fear. I can let it go and accept where I am and who I am — at least for the moment!

I see the day now with new eyes open to the breath of spirit moving through nature. I don't know if I can find any words right now. Making lines on paper with ink pen would be more satisfying.

L'église
qui chante.

But there is one thing to consider, and that is that we need to be healed again and again. I get so lost in the daily tit for tat, reacting to things encountered in the world or in my head which either please or distress me. One moment I'm thinking I'm pretty cool and then, in the next nanosecond, depending on what pops into my mind, I may find myself down there next to nothing — a tiny distrustful ant.

All the imaginary eventualities I fear and the stubborn resentments I entertain make me less than I could be. I could be radiating love to each being in the universe if I weren't so caught up in slandering my pure soul. If only I could forgive and accept imperfection and simply let myself and others be!

I don't find it easy to forgive myself if I notice negative behaviors toward other people. If, in my more subtle thoughts, I detect some agenda or meanness in my dealings, I don't find it easy to let myself off the hook. That is *if* I notice. It seems like I'm constantly trying to be more aware of it. That is, when I'm not caught up in some little resentment or competition or manipulation that makes me into someone I don't like very much. That's when I have to meditate and pray about it and pay particular attention to my dreams to try and uncover, to expose myself to myself.

I might try like hell to avoid getting to the bottom of things but I do it because I don't like to be in pain. I like feeling light and innocent, which comes from digging down to the source and noticing what's going on. Then I can decide whether some sort of apology is in order, which it quite often is. That way I can continually release myself from grumpiness and depression. At least that's what it seems like to me. It's hard to figure out what someone else is up to. In conflict there is so much to be learned!

Ah, but each day we get to start over. In fact we get to start over with each new breath of awareness. With each new thought, we have the possibility of reimagining ourselves, our world.

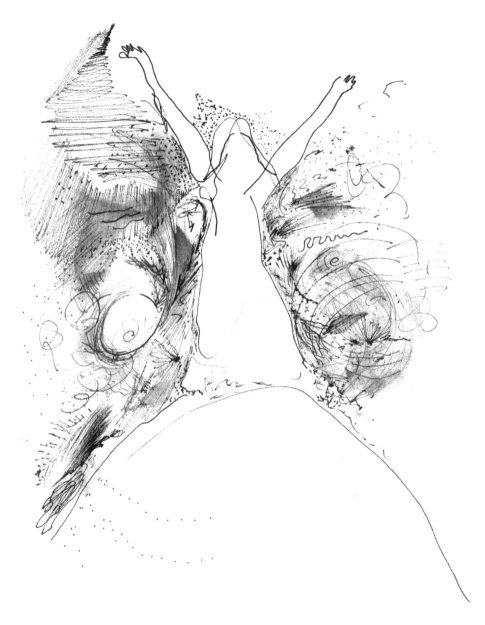

Watching the little white buttermoths chase each other, then dance in whirling ecstasy over clumps of purple-blue asters, gives me immense pleasure. I'm in such a state of contentment here in late September under my linden tree, imagining flowers I may plant one day in my garden.

Having given my last small dinner party by candlelight last night, I'm beginning to think of my apartment in Denver. I can't wait to ride the birdcage elevator up to the top floor — the fourth floor, my floor — getting out with my rolling bag and turning left, following the carpet around to my door, #4E. And I will be home. Home? But I am home.

This morning early, before the sun rose and I was trying to sleep, I discovered my "naysayer." I was chasing phantom tails of dreams and I just caught him out of the corner of my eye.

"My God! Who's that?!"

He was lurking in the back of my mind, a shadow, shaking his head slowly and muttering, "No, no, no."

It scared me to see so vivid a presence of total negativity. Aloud I said shakily, "Go away from me."

No wonder I have trouble in my life with him in my head! How do I stop him? Kick him out?

"GO! LEAVE NOW!"

I yelled at him but he stared at me like a big, dumb, stubborn lout, saying, "No."

He spoke to me. "Nothing you do will ever be good enough. Why bother trying?"

"You go away. You're not me!" But I felt otherwise. I *knew* that voice. It had been there a long time — way, way in the back of my mind — a constant, chanting, depressing voice.

I sat up in the predawn darkness.

"You frighten me, but I will find out more about you."

I didn't get any answers. But I knew he wasn't going anywhere. He wasn't going to just pack up and move out. He was part of me.

I did yoga breathing, and as my breath quieted, my mind expanded and I stared past him into the soft darkness. I felt movement in my heart and being, as if the universe were expanding. So quiet and deep, this holy darkness rich with presence. My hand reached out to feel, to gather in the darkness as if it were water. There was no name I could utter. Just vast silence and presence and a sense of being loved and held — all inclusive of my self, even my naysayer. Then there was my dancer, little dancing spritely self spirit joyously moving and gliding to deepest optimism. Little light and colorful being, I am so glad you're back!

Today I notice the money plant growing at the edge of the road alongside the hollyhocks. I go and break some off, rubbing it with my fingers to remove the membrane covering the seeds to make the shining "money" appear. I put it in the round earthen vase by my bed, where I kept lovely scented roses of early summer.

I hope the magic money plant will remind my unconscious mind to focus on abundance in all areas of my life. I certainly have an abundance of friends on the planet. And my daily life is filled with such beauty! I am thankful for my good health, and even though my vision seems a bit fuzzier than I remember, kind of like my mind, it gives a softer edge to reality. I can still see all the loveliness of the natural world.

And when I travel I can look deeply into the eyes of my brothers and sisters everywhere on Earth and see something of their souls. The music of humankind and the songs of birds sustain my heart. Such abundance!

But still, the little area that I seem to neglect, that needs attention, is daily down-to-earth sustenance — money. I'm not particularly good at generating that. In fact, I'm just as happy singing for my supper as I am singing for big bucks (which occasionally happens).

How is it that people can make all that money? Perhaps it is simply a matter of focus. So this morning, in my quiet reflective state, I send this out into the universe around me and hope the birds will relay the message into the right hearts: If there is anybody out there who would like to hear me sing, let them find me or let me find them!

Today I will make my calls to Paris and follow all leads.

An old woman walking by my house yesterday gave me three walnuts from the pocket of her housedress. She was very sweet and so hunched over that I had to bend over to see her face. She told me she was more than eighty years old, like Mme. Flouve and Mme. Tilleul, who sit daily and chat underneath the tree in front of Mme. Tilleul's house. They've spent their lives here working in the fields, dealing with the cows and sheep and their children and husbands. Their bodies are bent from hard work and sorrows but always through the changing seasons, they've had each other to talk with.

They are old enough to remember the night in 1944 when the entire village hid at La Serre, a farm on a hill above the road, watching the village down the valley burning in the darkness. They huddled together in their terror watching the Nazis in the distance as they marched up the road toward their village to punish the Maquis, the Resistance fighters. These sons and daughters of the tiny villages throughout rural France had made life hell for the Germans — like gnats and mosquitos bugging a berserk monster.

Something happened that night which is still considered a miracle. The Nazis stopped halfway up the hill and made camp by a small lake. The people waited at La Serre for the inevitable. But by first light the next morning the soldiers were gone. They had decamped suddenly during the night and headed north to the larger town of Saint-Céré to drag the young men from their beds and shoot them on the bridge over the canal.

I'm going to give Mme. Flouve and Mme. Tilleul and the other lady who gave me the walnuts each a little drawing of the village next time I see them.

Dancing through life, that's what we do.
We move in a direction and say,
"This is not where I thought I was going."
Pivoting, we shift our weight and we lift our arms
and maybe our foot and move or even stay put, swaying a bit.
Then suddenly, we twirl around
and off we go in another direction.
Always comes the impetus to move.
We follow the dance,
seeking balance and true expression.

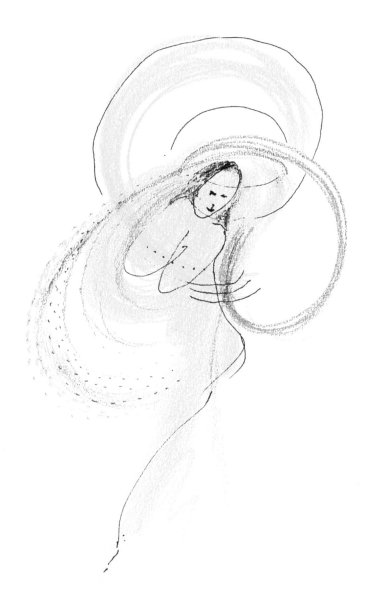

Standing on my balcony just now, looking out over the hills of Quercy, the lines of land-scape against the sky of many shapes. I'm twelve years old standing at the prow of a ship sailing out of New York harbor on a bright August morning. I can smell the ocean on the freshness of the breeze as I stand and wonder, "What will my life be?"

As a child heading to Europe I felt the delicious excitement of things to come. I was moving worlds away from my little town in the foothills of Colorado. A photo shows me with my hair in braids standing next to a ship's life preserver. I am holding two little dolls and smiling. Later on, there is a photo of my family sharing a picnic by the side of the road on our way from Paris to Nice. My hair is soft and loose and there is something different about my face. My eyes have a new awareness, as if I'd heard and seen things that would forever change me. I had put away my dolls and was ready to step into the world of adolescence. My mother had bought me perfume in Paris!

When I draw I rarely know exactly where I'm going. I watch the pen move on paper or spread the color around wondering what might be trying to express itself. My art doesn't have to look like any particular thing; it just has to reflect my peculiar aesthetic sense of balance. It's a little scary launching into a piece of art, facing the blank page and wondering if it will work this time. The reason I find the courage to begin is that I discovered a long time ago how to make a blunder — a smudge or a line gone awry — into something else. How to move in a new direction and let an unforeseen and friendlier shape emerge from a "mistake."

But what am I to do with this love that has appeared from out of the blue? This man who arrived on my doorstep with a disarming smile and a bottle of fine Bordeaux. I didn't hesitate for an instant to invite him into my house, into my life. That's because when I looked into his eyes I saw my future. I saw *him* in my future. I had met him on one of Pierre's château tours and immediately liked him. But here on my balcony in the moonlight, I felt I'd known him far beyond time and memory. And later, when we pressed our hearts together, it seemed as if the two of us ascended, dancing alone together in the ether.

Yes, it happened quickly. So quickly that I'm a little shaky and I don't know what to do. And I'm scared. He has entered my solitude. Is this all right?

One thing that is both good and bad: he is a traveler. And his life is complicated. He comes and he goes so I have plenty of time to ponder all this. And I'm pretty sure it is a love that cannot be denied. Yet he came and after some days he went away. Will this new love also come and go?

The day after he left, I got in my car and meandered many miles on the back roads to an ancient abbey in the village of Conques. I made my pilgrimage there to offer all my

evolution of love

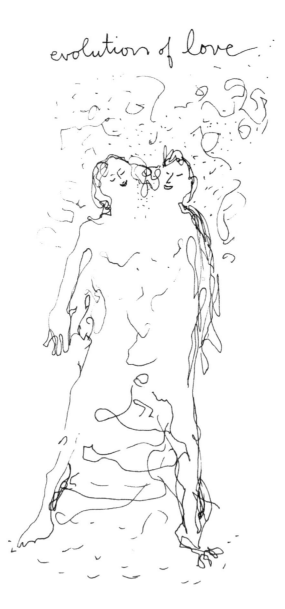

hopes, my fears and my utter confusion about this occurrence. My heart called it love, but I was frightened. I was quaking in my boots. I felt like a baby taking its shaky first steps — afraid to fall all the way into love.

After all my high flown philosophizing was I going to slam the door (of my own heart) shut?

Sitting in sunlight in front of a tiny side altar graced with a bouquet from someone's garden, so lovely in its simplicity, I meditated and prayed for a long time. The Madonna became to me the source of all compassion and love, the feminine spiritual presence I've desired above all things.

The church had emptied out the few fall tourists and was absolutely still and quiet. I felt the presence of Divine Mother in all her many forms wrap me in her arms as I uttered, "I am yours. All I truly want is to be with you. Let love come or go. I am yours."

There was a sort of shuffling sound in the abbey, and I heard beautiful Gregorian chanting. I turned to see a small group of white-robed monks walking as if on air down the nave toward the high altar, singing all the while.

I was in an ecstasy — so still, as in the deepest meditation, my soul resonating with the sound of the chanting as it moved closer to where I sat barely breathing. They came and gathered behind me and spoke some words in Latin, which felt like a holy benediction sealing my troth with Divine Mother.

I feel it even now. And as I think about this new love in my life I say, "I can relax and let it happen for I am essentially free. Whether this love stays or goes, I am all right." But I hope somehow it will stay.

I sit down to write but can't. All I can do is watch the last beautiful Monarch flying around my garden. After some time I suddenly jump up and begin to dig like a madwoman. I dig laboriously down through so many layers of clay and stone as I'm used to doing in the foothills of the Rockies. Only here there are ancient foundations of walls where I sometimes find the crusted tools of the old ones. Today I find a chain of hammered iron links with a great round piece on the end which, I imagine, tethered a giant oxen. I bring shovelfuls of compost and the richer soil found under trees or in mounds left behind by moles. I work it into the hole I've just dug with my sweat and aching muscles. All this I do so that as I sit admiring my garden a year from now I will see before me an even more beautiful landscape — one that was just beyond my imagination when I arrived here.

I'm bringing the pillows in from the chairs on my balcony. The birds are flying around like mad, getting ready for winter. It's misty but not terribly cold yet and I like imagining the roots of my plantings reaching deep into the garden's soil where they'll be safe from frost. Such an exciting time! I wonder who I'll be when I return next year. Right now I still need to hang my walnuts from a beam in my *grenier* so that if a mouse happens along he won't be able to get at them.

Waking at four or five in the morning, I feel France here inside me as if it were coursing through my blood, as if my inner landscape were France itself. The soft-colored stone sculpture of mother and child, which Pierre made for me because I sang on the château tour, gives me such sweet joy. (I will haul it home to America in my suitcase!) I've discovered that singing here, in these intimate settings, I can share my secret self — the unseen

presence that inhabits my days and exists beyond language. The rhythm in my bones, the song bubbling up out of me like a deep rock source of magic waters that I can share through my eyes, my body, my voice — like watering thirsty souls. This is the gift *la belle* France has given me.

France has given birth to the joyous artist in me … and brought me a whispered promise of love. Now, for the moment, I can leave.

~ FINI ~

One thought occurs to me as I embrace
both my feminine and masculine sides —
I join collectively with others involved in
the same work. As a woman I manifest
my connection with what I call Divine
Mother — the feminine face of God. It is
this strength and energy that has seen
me safely thru these changes.

But it is not the exclusive domain of women
certainly! Men are also seeking and
discovering new pieces of themselves — as
we all move toward wholeness.

We are two sides of the same coin —
The yin/yang dynamic — ongoing. Yin trans-
forming yang, yang transforming yin.

We are moving toward balance,
toward healing of ourselves and
ultimately the whole planet.

remm:

CPSIA information can be obtained
at www.ICGtesting.com
Printed in the USA
LVHW071557010322
712330LV00021B/1339

9 781944 243098